URBAN ORE

SOMA
san francisco

URBAN ORE

MARC KITCHEN–SMITH

FOR THE SOMA EDITION		SPECIAL PHOTOGRAPHY BY	FOR THE HAMLYN EDITION	
PUBLISHER	JAMES CONNOLLY	Tom Mannion	COMMISSIONING EDITOR	NINA SHARMAN
EDITORIAL DIRECTOR	FLOYD YEAROUT	Mark Winwood	CREATIVE DIRECTOR	KEITH MARTIN
EDITOR	RITA SIGLAIN	Mel Yates	EXECUTIVE ART EDITOR	MARK WINWOOD
PRODUCTION	JEFF BRANDENBURG		DESIGN	BIRGIT EGGERS
COVER DESIGN	STEVE BARRETTO		PICTURE RESEARCH	CHRISTINE JUNEMANN
COVER PRODUCTION	FLUX		PRODUCTION CONTROLLER	LOUISE HALL

© 2001 BY HAMLYN, AN IMPRINT OF OCTOPUS PUBLISHING GROUP LIMITED, 2–4 HERON QUAYS, LONDON E14 4JP

FIRST PUBLISHED IN GREAT BRITAIN BY HAMLYN. NORTH AMERICAN EDITION PUBLISHED BY SOMA BOOKS BY ARRANGEMENT WITH HAMLYN

SOMA BOOKS IS AN IMPRINT OF BAY BOOKS AND TAPES, INC., 555 DE HARO ST., NO. 220, SAN FRANCISCO, CALIFORNIA 94107
LIBRARY OF CONGRESS CATALOGING-IN-PUBLICATION DATA ON FILE WITH THE PUBLISHER
ISBN 1-57959-067-5
10 9 8 7 6 5 4 3 2 1
PRODUCED BY TOPPAN – PRINTED IN CHINA
DISTRIBUTED BY PUBLISHERS GROUP WEST

URBAN ORE® IS THE REGISTERED TRADEMARK OF URBAN ORE, INC., 900 MURRAY ST., BERKELEY, CALIFORNIA, 94710, WHOSE PURPOSE IS "TO END THE AGE OF WASTE" THE COMPANY RECOVERS REUSABLE GOODS AND OFFERS THEM TO THE RETAIL PUBLIC, PUBLISHES MATERIALS ON THE SUBJECT AND PROVIDES INTERNATIONAL CONSULTING AND DESIGN SERVICES TO THOSE INTERESTED IN THE GOAL OF ZERO WASTE. THE TRADEMARK IS USED HERE UNDER LICENSE.

INTRODUCTION 6

INSPIRATION 10

STYLE PALETTE 20

1 MINIMALIST ART GALLERY 24
2 BOHEMIAM ECLECTIC 30
3 INDUSTRIAL CHIC 36
4 WAREHOUSE RUSTIC 44
5 GLOBAL STYLE 50
6 CLASSICAL 56
7 SOFT MODERNISM 64

CREATING SPACES 70

ROOM SETS 78

LIVING AND DINING AREAS 80
KITCHENS 88
BEDROOMS 96
BATHROOMS 104
WORKSPACES 112

COLLECTING AND DISPLAY 116

ACKNOWLEDGMENTS 124

INDEX 126

Links geh
Benutzung

INTRODUCTION

FOR THOSE WHO LIVE IN A CITY OR LARGE TOWN, IT CAN BE VERY MUCH A LOVE-HATE RELATIONSHIP. WE HATE THE TRAFFIC JAMS, THE POLLUTION, THE LITTER, THE CROWDED PUBLIC TRANSPORTATION, THE NOISE, THE STRESS, THE LACK OF SPACE AND ALL THE OTHER UNFORTUNATE THINGS THAT SEEM TO GO HAND IN HAND WITH URBAN ENVIRONMENTS.

DESPITE THIS, IF WE WERE TO MOVE OUT OF THE METROPOLIS, MANY OF US WOULD MISS SOME OF THE VERY BEST ASPECTS THAT URBAN LIVING HAS TO OFFER — IN PARTICULAR, THOSE ELEMENTS OF THE CITY THAT CONTRIBUTE SO MUCH TO THE INTERIORS OF OUR URBAN HOMES, SUCH AS THE ENDLESS ARRAY OF INSPIRATION AND THE INFINITE RANGE OF RESOURCES VIRTUALLY AT OUR FINGERTIPS. THE KEY ELEMENT THAT PROVIDES US WITH THIS VAULT OF INSPIRATION AND RESOURCES IS THE URBAN LANDSCAPE ITSELF.

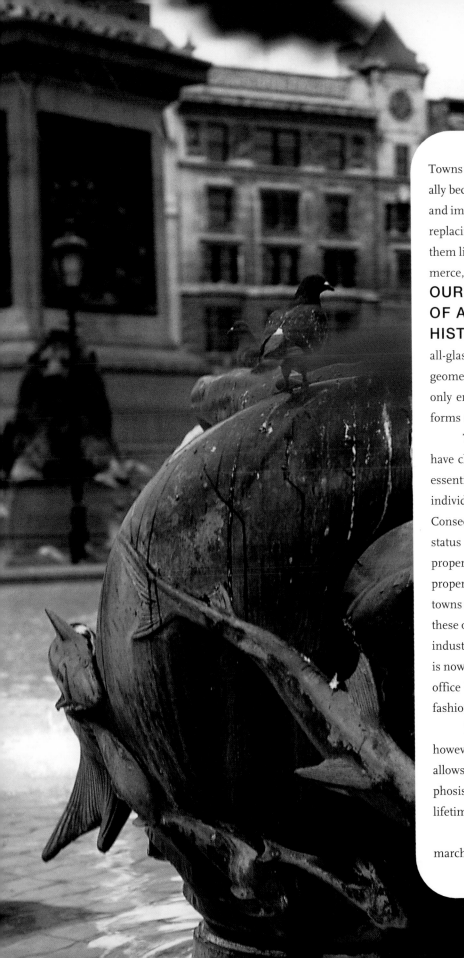

Towns and cities originally started life as strategically located settlements that gradually became slightly larger hamlets and villages. Over the centuries, as the populations and importance of these sites grew, more and more buildings were constructed, either replacing the existing smaller, less substantial examples, or growing up alongside them like sprouting limbs. In the name of progress and the natural evolution of commerce, this process has continued decade after decade so that **TODAY WE FIND OURSELVES SURROUNDED BY AN ECLECTIC MIXTURE OF ARCHITECTURAL STYLES FROM MANY PERIODS IN HISTORY**. Classical Georgian townhouses rub shoulders with state-of-the-art, all-glass office buildings; rococo palaces are discreetly sandwiched between postwar geometric art galleries and public housing complexes. This collage of architecture not only enriches our lives but also provides some of the most interesting and diverse forms of accommodation for urban dwellers.

The development of computer technology and worldwide access to the Internet have changed the face of business and industry in towns and cities. It is no longer essential for companies to be located in the heart of major cities and towns, and individuals can successfully work from home, therefore not requiring office space. Consequently, companies have found it uneconomic to sustain their sprawling urban status symbols, preferring to relocate to smaller buildings or move to commercial properties on the outskirts of towns. Many of these former business or industrial properties are now getting a new lease on life. With the ever-increasing populations of towns and cities, there has been a noticeable move over the last two decades to recycle these old buildings into new urban homes. This urban regeneration of commercial or industrial properties has created some unusual living spaces for people. Urban living is now becoming synonymous with having an apartment in diverse buildings such as office buildings, banks, churches, schools, hospitals and warehouses—or what are fashionably called "lofts."

Not all buildings are saved from the bulldozer to be turned into homes, however. Demolition still has an important role to play in the urban environment. It allows contemporary styles of architecture to emerge and continue the metamorphosis of the urban skyline, which, whether we personally appreciate it in our own lifetime or not, will undoubtedly inspire future generations of urbanites.

Change is inevitable, whether we regard it as for better or worse, and progress marches on. We do, however, have more control over the world within our own four

walls. If one of the downsides of urban living is being forced to occupy the same generic space as hundreds of other people—at work, in the street, or socially—the upside is knowing that we still have our own unique space to retreat to. Often it is the only place where we can declare our individuality and make a strong statement about our existence. Whether we do it intentionally or inadvertently, we decorate our homes in various ways to reflect and complement our personalities. Which colors excite us? Which textures and surfaces make us feel good? Which furnishings are we prepared to share our valuable space with? Which fantasy do we want to relive? These are all questions we eventually answer for ourselves when deciding upon the ideal look we want for our home.

With so many individuals—each with unique tastes and passions—living in such condensed areas, it can be no surprise to find remarkable diversity of urban interior styles. Behind the façade of a single building there may be thirty, forty or even more individual apartments, each with their own interior style. Like a series of theater sets, the difference between them can be quite dramatic. One interior may be painted entirely white, with minimal furnishings, tidy and with a Zen-like quality, while only a brick thickness away another apartment may be bursting with fuchsia-pink walls, luxuriant Bohemian-style sofas and an Aladdin's cave of eclectic trinkets and objets d'art.

As will become clear in the following chapters in this book, **URBAN CHIC IS NOT ONE SINGLE INTERIOR STYLE BUT A COLLECTION OF STYLES THAT HARNESS THE ESSENCE OF URBAN LIVING**. It is where urban life has had an influence over interior decision-making, through factors such as the resources it has to offer, the inspirational material that can be drawn from it, its styles of architecture, its location, the available size of living space, budget restraints and people's lifestyles.

I have chosen a varied and interesting cross section of urban styles to feature in this book, which I feel tackle some of these issues, and which illustrate the key components to consider when deciding upon the final look for your home. Whether the featured styles suit your taste or not, at least their dissection will provide a process by which you can approach your own room-interior projects. Ultimately, remember that the very cosmopolitan nature of city life allows you to express yourself. Be adventurous and daring when it comes to decorating your home, and do not hold back. Be confident, and create your castle.

WHAT IS **INSPIRATION?** INSPIRATION IS THAT ELUSIVE SOMETHING THAT SPARKS AN IDEA OR FEELING INSIDE AND SUBSEQUENTLY MOTIVATES YOU INTO ACTION OR CREATIVITY. THE URBAN ENVIRONMENT IS BURSTING WITH IDEAS, BOTH ORGANIC AND MAN-MADE, TO HELP YOU BEGIN DESIGNING.

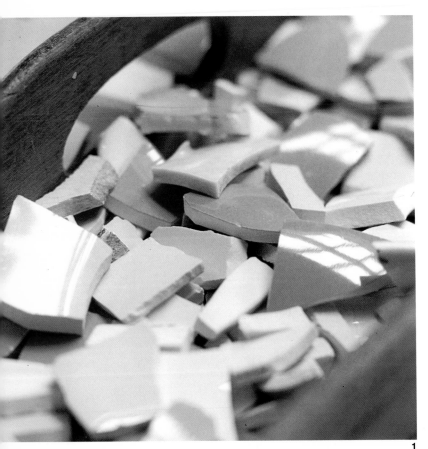

Before you start decorating your home, you will need some form of inspiration—the seed of an idea that will develop into the interior style of your choice. This style should suit your type of home and also be comfortable to live with for a reasonable period of time, for, as we all know, the effort and money involved in interior decorating generally prohibits people from doing it too often.

Inspiration is intangible because it is an emotional sensation, and one that varies considerably from individual to individual. Much more tangible, however, are the many potential sources of inspiration—details on architecture, the basic goods in stores and markets, colors of fashionable clothes, the ambience of a gallery or museum. In fact, almost everywhere there is some form of inspiration to be had. It does not always leap out, but it is there all around nonetheless, gently coaxing and influencing us into deciding what our own definitive taste is. More often than not it is the things we do not like that help us make up our minds, the process of elimination that narrows down our options until we get to the point where we can say: "Yes, that's what I like."

We pass some sources of inspiration every day as we walk to work or ride in a car or on a bus; for other examples, we may have to search. Here, the urban dweller is at the greatest advantage, thanks to the sheer variety and easy accessibility of inspirational sources available to him or her. Art galleries, street markets, specialty shops, international newsstands and even useful items of trash are all perks of city living that help promote the diversity of urban interiors.

1

WHERE TO FIND INSPIRATION

Everywhere you go, you will be surrounded by inspirational material. Look at it with an open mind and decide if it is right for you. While some inspiration comes from just taking note of the immediate world around you, "found" inspiration comes from objects and materials that you can physically pick up and take away with you.

The most obvious place to look for inspiration is in one of the many glossy interior decorating magazines. These are a great place to start your hunt for ideas, but there is always the slight drawback that the solutions they offer are somewhat prepackaged, and essentially put together by some other person. Make it more exciting for yourself by turning interior-detective, exploring what else the urban environment has to offer. Remember, finding your own solutions will give your interior a unique look.

As you set off on your expedition, be prepared to view objects, materials and details in a new light. For an industrial chic style for your home, take a clear look at the general fabric of the urban environment: the different combinations of materials such as brick, glass, concrete and steel; the slick finishes produced by marble and chrome and the subtle differences between polished and brushed aluminum. The overall effect of these materials on each other is openly there for you to study at leisure, and for free.

If the more "gritty" side of the city is not for you, do not dismiss the rest of the urban environment. Inspiration can literally be beneath your feet downtown. It could be the herringbone pattern of bricks in a sidewalk or the decorative design on a manhole cover; or perhaps that mosaic-covered entrance to a store might suit your bathroom floor.

The urban environment automatically generates an air of competitiveness. Billboards become more daring in order to attract attention, architecture becomes more avant-garde and adventurous, and downtown stores and restaurants become more inventive and striking with their corporate identity in a bid to persuade customers to purchase their products rather than those of their neighbors. Next time you go out for some coffee, look more closely at the designs of restaurant countertops and the choice and combination of sandblasted glass, wall tiles and recessed lights—it could be the solution for your kitchen.

Living in the city should mean no excuses for not visiting the latest art exhibits. In galleries and museums we are exposed to the freshest, most innovative ideas in design and technology. We can experience the cutting edge in furniture, lighting and fabrics, and be inspired by a vision of the future. Without even leaving the city center, we can visit exotic and mysterious locations all over the world through international photography exhibits. Pictures of foreign architecture, customs and fashions can be all it takes to inspire you to adopt a complete global look for your home. For instance, visiting a painting exhibit by the artist Karl Larson, featuring aspects of his home life

[1] A collection of broken crockery is stored in an old cutlery tray waiting to be utilized for mosaics. Materials like this can be used to customize mass-produced items bought downtown.

[2] The simple geometry of modern buildings juxtaposed against the intricate detailing of period architecture is one aspect that makes the urban environment so interesting.

[3] The combination of materials used in familiar everyday street furniture can provide ideas for unique style solutions for your home, especially when aiming for an urban chic look.

[4] Texture is as important as color and design combinations. In the street, look for unusual textures. For minimalist homes, consider playing rough surfaces off against smoother ones.

2

3

4

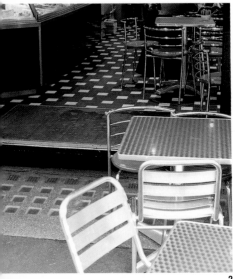

[1] Besides the brash artificial colors of street signs and posters, look out for more subtle colors produced by the patina of age. In this example, a piece of copper demonstrates what the ravages of time in the city have done, oxidizing it to a beautiful verdigris color.

[2] Cafes are a great source of exciting and eye-catching colors and materials. Their cohesive design is usually created by good interior designers and architects who know how to make individual details work well together. Do not be afraid to "steal" ideas and adapt them for your own purpose—they will always look slightly different after you have reinterpreted them.

[3] Dumpsters can generate rich pickings for those with a keen and ever-watchful eye—from unwanted materials to antique furniture worth a fortune. Look for unusual items that could possibly customize something you already have.

like painted furniture, paneled walls and fretwork shelving, could be all the inspiration you need to go ahead and recreate a nostalgic Swedish country interior.

In museums, you can catch a glimpse of how our ancestors once lived and from that glean what style you would like to steer your home towards—such as baroque, Arts and Crafts or Art Deco. It might not even be the exhibit that inspires but the venue itself: a clean, white, spacious gallery look might be exactly what you are searching for, or maybe the dusty, archaic ambience of a Victorian museum building. If you like the mood of an interior and want to recreate it in your own home, make a note of three things: color, materials and lighting. These are the key elements that create mood or ambience.

Inspiration derived from objects or materials can be used as a reference point for an idea, color shade or texture, or can even become the focal point of a room. If you are trying to decorate your interior on a shoestring budget, then acquiring pieces of inspiration need not cost much, if anything at all. Found items of inspiration can be rewarding in many ways. One of the by-products of the urban environment is the amount of trash generated daily from households, offices and retail stores, and from building and demolition and construction sites. Most of it can be recycled in one way or another, depending on how resourceful you are. A common sight in any town or city is the dumpster. These large receptacles, used for the removal of trash, can be a rich source of inspirational and reusable materials, depending on their location.

When found in residential areas, the chances are that the dumpster is being used for a house clearance. Look out for interesting, and even valuable, antique or modern furniture that can be renovated and given a new lease on life. If you spot a dumpster near a demolition site, have a glance into it as you walk past. There are still many good-quality architectural odds-and-ends thrown away rather than taken to salvage yards. Look out for old door fittings, paneling, period moldings and cornices, or even fragments of decorative plasterwork. Even the tiniest fragment of "discovered" history incorporated into your home in some way will bring intrinsic qualities with it that could never be found in a downtown store purchase. Dumpsters next to construction sites can yield a great cache of new building materials. These dumped, leftover materials offer the decorator a source of free goods, plus the chance to find less familiar, industrial-type elements not available through normal domestic outlets. A piece of a rare pattern marble, or a sheet of steel with an interesting texture, could provide a dynamic piece of inspiration for your home.

Trawling through a few dumpsters around town could send you home with perhaps a piece of brand-new carpet for your hallway, some unwanted wooden scaffolding planks, which when sanded down and stained will make good, rustic shelving, or even an old office chair from the 1930s, which, after a little attention, will make a stylish chair for your workspace at home. Besides the serendipitous aspect of found inspiration, you will also have the pleasure of knowing you have "recycled" something, as well as the kudos of being able to tell friends that it cost you nothing.

Other forms of found inspiration can be picked up in city parks or on riverbanks, and even dug up in your urban garden. Remember, inspiration can be something you incorporate directly into your home, or just keep as a reference point. So next time you are looking for a color scheme for one of your rooms, try uniting objects that possess the same color hues that you are naturally drawn to. An example might be placing an ordinary egg and a terra-cotta brick on a sheet of butcher paper. In this grouping you may have a color range of beige, dusky pink, and pinkish brown. Besides creating a unique color scheme for yourself, with this method it is sometimes easier to see how colors work on a collection of surfaces, rather than using the tiny color swatches you normally get from paint stores. The importance of this is to ascertain how colors are altered depending on how the light falls on them. Looking at color on three-dimensional objects allows you to gauge how that color changes from the shadow to the highlight areas. Of course, once you have found a "palette" that works for you, use the traditional paint swatches to match the color of the objects to enable you to order the correct shades. The trick to finding inspiration for your home is to keep your eyes permanently peeled. You could quite easily see a scrap of paper lying on the pavement that is the precise color shade you are looking for. Pick it up, and now all you have to do is try to match it at the paint store.

[4] Cast-iron gates stacked against a wall in a salvage yard show off their patina of weather and age. They could be used indoors as a screen to separate areas within a room. Leaving the rust on them will give an antique quality to the interior.

[5] Unusual and quirky items, such as these cinema seats found in a junk shop, have the potential to become the main conversation piece of a room. Try to visualize beyond what you see—it would be quite easy and relatively inexpensive to reupholster these seats in a new fabric.

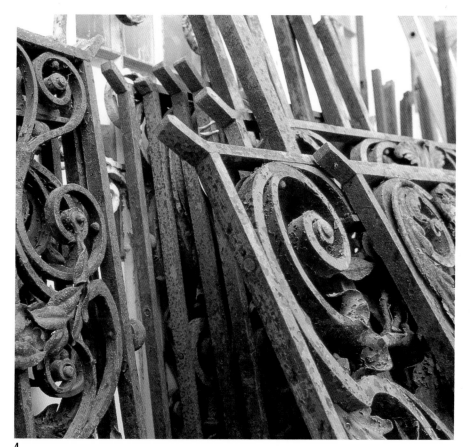

4

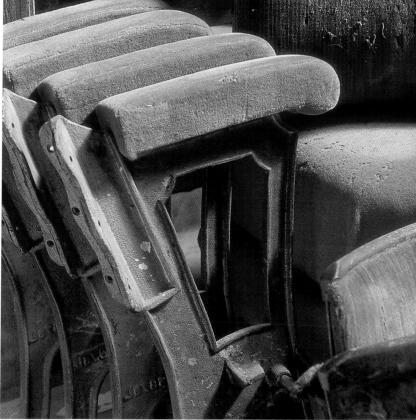

5

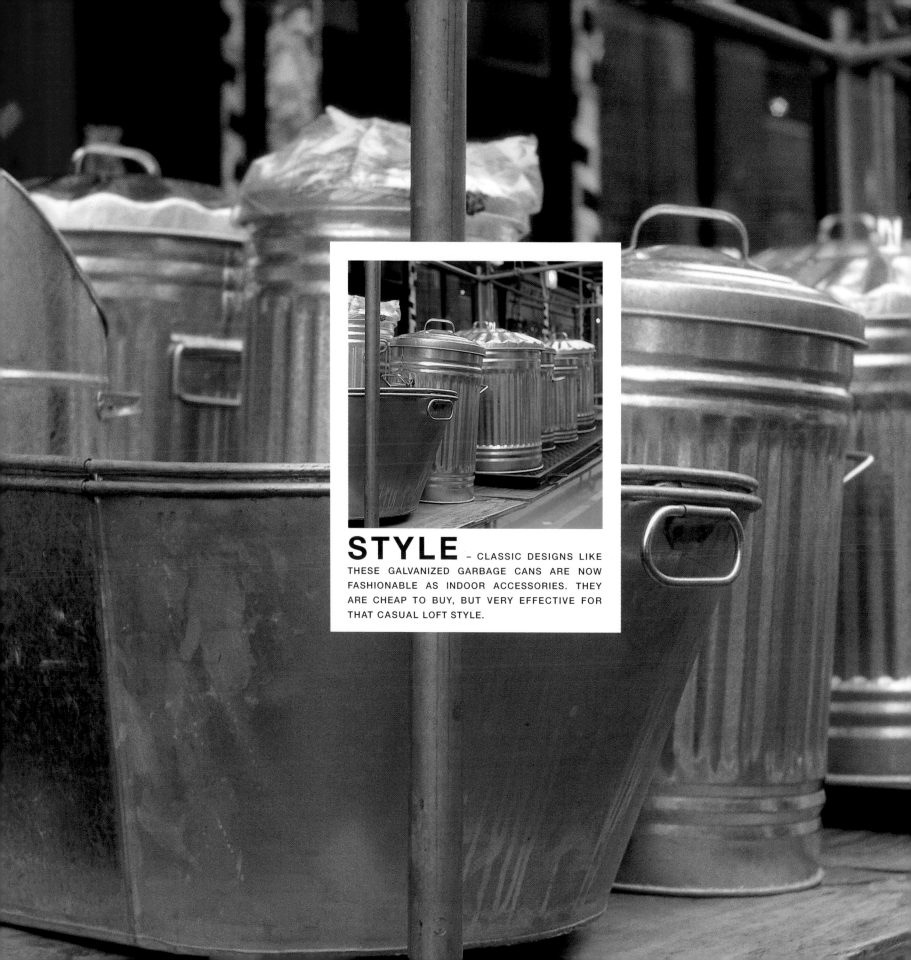

STYLE – CLASSIC DESIGNS LIKE THESE GALVANIZED GARBAGE CANS ARE NOW FASHIONABLE AS INDOOR ACCESSORIES. THEY ARE CHEAP TO BUY, BUT VERY EFFECTIVE FOR THAT CASUAL LOFT STYLE.

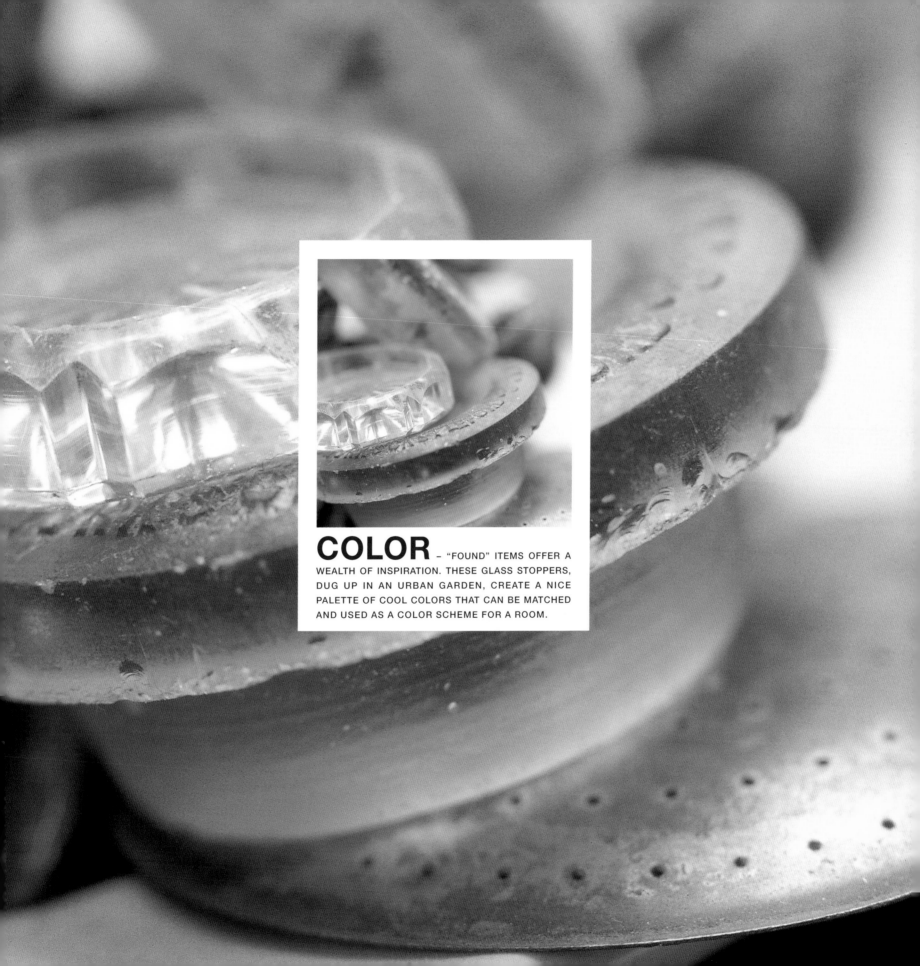

COLOR – "FOUND" ITEMS OFFER A WEALTH OF INSPIRATION. THESE GLASS STOPPERS, DUG UP IN AN URBAN GARDEN, CREATE A NICE PALETTE OF COOL COLORS THAT CAN BE MATCHED AND USED AS A COLOR SCHEME FOR A ROOM.

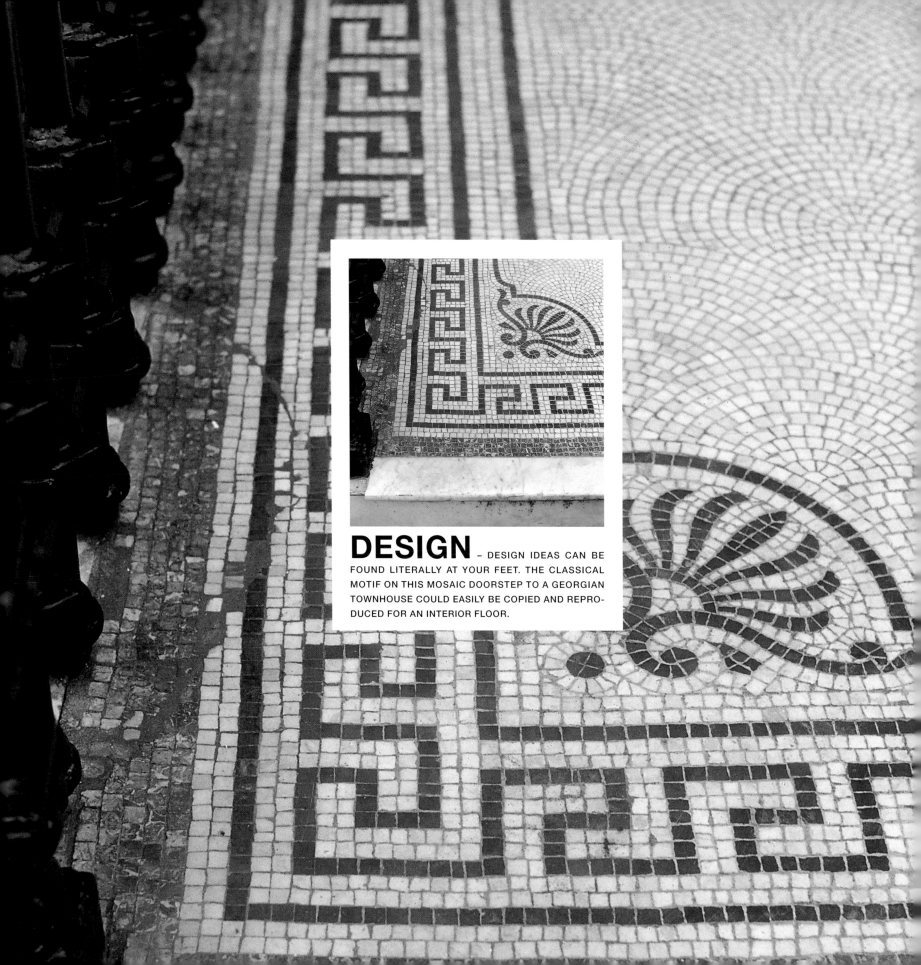

DESIGN – DESIGN IDEAS CAN BE FOUND LITERALLY AT YOUR FEET. THE CLASSICAL MOTIF ON THIS MOSAIC DOORSTEP TO A GEORGIAN TOWNHOUSE COULD EASILY BE COPIED AND REPRODUCED FOR AN INTERIOR FLOOR.

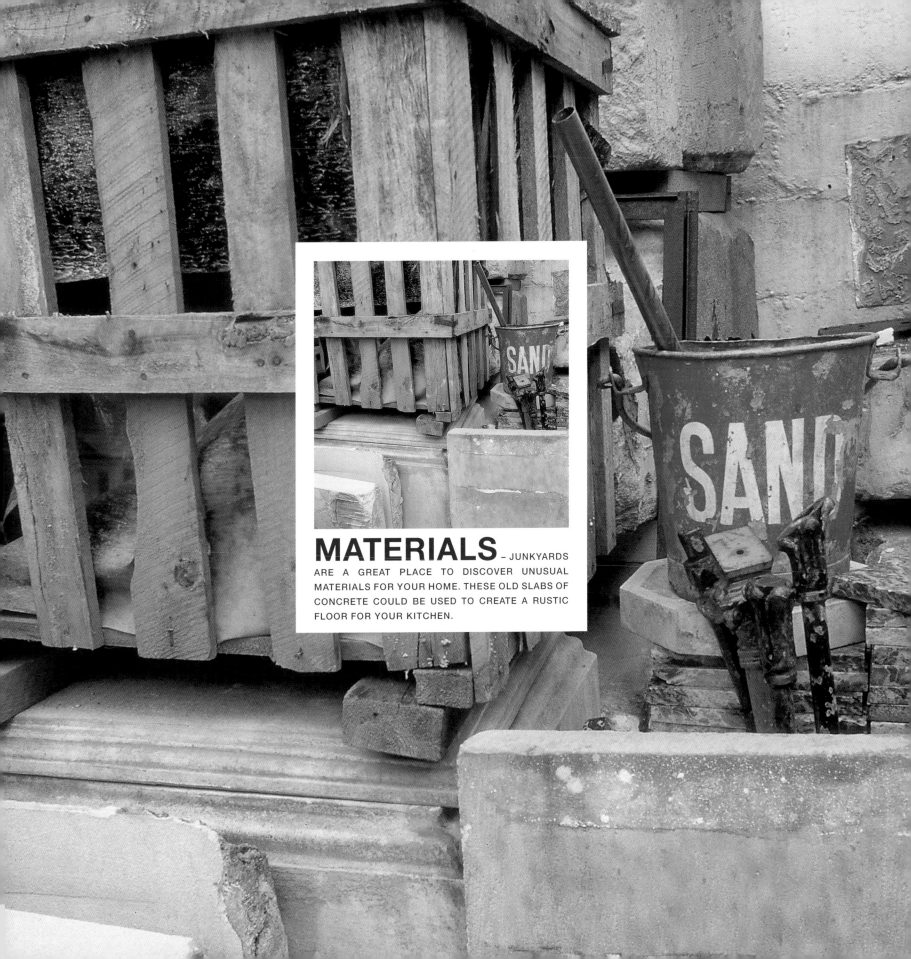

MATERIALS — JUNKYARDS ARE A GREAT PLACE TO DISCOVER UNUSUAL MATERIALS FOR YOUR HOME. THESE OLD SLABS OF CONCRETE COULD BE USED TO CREATE A RUSTIC FLOOR FOR YOUR KITCHEN.

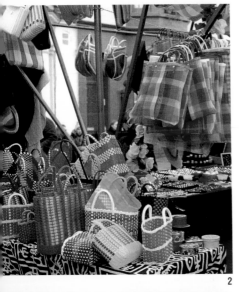

[1] Architectural salvage yards like this one are an interior decorator's heaven, displaying the wide range of period details and street furniture that are saved from obscurity when buildings are demolished or modernized.

[2] This eye-catching market stall displays a great range of brightly colored plastic baskets, probably Mexican in origin. It could take just one of these bags to set you off on an entire Mexican-themed interior.

[3] Visiting stores that specialize in imported products from specific countries is an easy way to create the global style of your choice. This one specializes in colorful products from Mexico.

SOURCES OF INSPIRATION

There is a wide range of inspiration sources in the city. From retail stores and markets to lumberyards and dumpsters, just let your imagination take you wherever you want to go.

If you are not lucky enough to find what you are looking for in a dumpster, try an architectural salvage yard instead. These are the graveyards of some of the best architectural detail, saved from demolition sites or buildings in the city that are undergoing renovation. Visit one of these yards and it is guaranteed you will be inspired by something. Architectural salvage yards carry a great variety of original period pieces such as doors, windows, radiators, paneling and floorboards. Such elements can be reinstated into period homes where the original details have long been stripped out after years of modernization. Alternatively, take isolated elements, complete with dents and flaking paint, and reuse them in a more inventive way. Ornate wooden or plaster corbels that once made decorative supports beneath interior lintels could instead be used as very grand shelf brackets. Tall window shutters, hinged together, could make a free-standing room divider.

The owners of these salvage yards are quite happy for you to browse, and this is definitely the best way to discover the unexpected. Inspiration can strike when you suddenly spot an unusually shaped window frame. You simply *must* have it, and so your imagination works overtime to come up with a way of using it—maybe it could form a unique partition between your kitchen and living room. This is the power of inspiration. What excites one person might not excite another, however. For someone else, a beautiful fragment of stained glass might be what it takes to set the entire direction of a room. If you have the space and want to make a real statement, consider using an architectural detail normally associated with exteriors. Salvage yards often have very unusual items in stock, such as clock-towers, water fountains and gazebos.

If "quirky and unusual" is the style you want for your interior, wander around some of the many open-air markets in the urban environment. Market stalls tend to be a gauge for what the overriding culture is in a specific area of a city. They reflect the tastes and requirements of their predominant customers, whether these be Asian, Mexican, African, or another. In our modern multicultural world, the main cities become the melting pots of nations, in which the fusion of different cultures begins and evolves. This is another excellent feature for urban dwellers to take advantage of. Besides the imports of fashions, exotic foods, spices, cars and customs come the decorative and even household items. When taken out of the context of their country of origin, these often take on an attractive appeal. From the convenience of our own city, we can create a look in our homes that conjures up the essence of another land— maybe a land we once visited on vacation, fell in love with, and now wish to recreate in

our homes so that we can "be there" every day of the year. It might be a desire for the exoticness of eastern Asia, or the warmth of the Mediterranean. There are also many stores that specialize in foreign imports, and these are a good source for the global look—from Latin America to India.

When you are looking for unique but inexpensive ideas for your home, department stores can have the answers, providing you are prepared to view things with a completely different approach. Look for potential. You can buy a basic mass-produced item like a chair, table or bookcase from a regular department store and then personalize it to suit your own taste. Customizing is one way to create something unique for your home. Another is to buy items that are normally manufactured for a specific use and to give them a completely different one in your home. Familiar objects and materials taken out of context, and given an alternative use, could add that eclectic twist that your interior needs.

Hardware stores, for example, are good to visit when you are looking for inspiration. They stock a wide range of objects and materials, particularly those of the more old-fashioned type, which provide a wealth of potential interior ideas. Also seek out specialty shops for inspiration. For instance, when browsing around a ship chandler's shop you will automatically start to wonder how you might incorporate some of their thick colored ropes, or those distinctly nautical cabin latches, into your home.

Truly individual interiors are nearly always an interesting mix of bought and found objects, mass-produced and customized, and a healthy cocktail of old and new. A great example of mixing the old with the new to successful effect is what can be described as "contemporary retro-styling." This incorporates original pieces of furniture and objects from the 1950s, 1960s and 1970s, and cleverly integrates them with good examples of modern design. Objects designed throughout the postwar years represented quite a drastic leap from the austere designs of the 1940s and earlier. Developments in materials and technology, such as laminates and plastic molding, enabled product designers to push their imaginations to the limit. It meant that many of the objects designed during the 1960s and 1970s were way ahead of their time, and considered too avant-garde for most people's taste. Today, organic shapes and futuristic styling are fully appreciated, and certainly do not look out of place or too old-fashioned. As with any retro look, choose classic examples that epitomize their era, and mix with modern examples that have similar qualities or lines. Some of the classic retro examples are actually being reproduced today, such as the inflatable plastic furniture of the 1960s. The look should be clean, fairly minimal and easy-living, which particularly suits the open-plan arrangement of loft-style apartments.

Whatever inspiration you are looking for, it is out there in the urban jungle. Even if you do not know exactly what it is that you should be looking for, just go for a walk in your own urban backyard. The city is just one big three-dimensional catalogue of styles, colors, designs and materials—it is up to you to make the most of it.

DO-IT-YOURSELF (DIY) SHOPS OR HOME STORES | SHELF UNITS, CHAIRS, LAMPS, LIGHT FITTINGS, STORAGE. ALL CAN BE CUSTOMIZED OR USED AS IS.

HARDWARE STORES | GALVANIZED GARBAGE PAILS, BUCKETS, WATERING CANS (FOR PLANT CONTAINERS), KITCHEN STORAGE, CHAINS, UNUSUAL DOOR AND GATE LATCHES, ETC.

SHIP CHANDLER'S SHOPS | COLORED ROPES, BOAT LATCHES (AS KITCHEN OR BATHROOM FITTINGS), CANVAS. GOOD FOR SEASHORE, NAUTICAL OR BEACHCOMBER LOOK.

GARDEN CENTERS | TERRA-COTTA CONTAINERS (DISTRESSED OR USED AS IS), FENCE MATERIALS (FOR WALL TEXTURE OR MAKING SCREENS), RUSTIC ITEMS.

DUMPSTERS | FREE RAW MATERIALS AND ITEMS THAT INSPIRE. GREAT CONVERSATION PIECES.

LUMBERYARDS | GLASS BRICKS (FOR PARTITION WALLS AND SHOWER CUBICLES), CONCRETE BLOCKS, DRAINPIPES (AS PLINTHS), GRAVEL (FOR INDOOR LANDSCAPING).

ARCHITECTURAL SALVAGE | WINDOWS, DOORS, SHUTTERS, FLOORS, PANELING, BATHROOM FITTINGS. SALVAGE FROM TAVERNS, SHOPS AND CHURCHES. ALL CAN BE USED IN TRADITIONAL OR INVENTIVE WAYS, SUCH AS WINDOWS TO DIVIDE INTERNAL SPACE, STAINED GLASS FOR PRIVACY IN BATHROOMS. WEATHERED DOORS AND SHUTTERS (AS SCREENS OR TEXTURAL BACKDROPS FOR HANGING PICTURES OR DISPLAYING COLLECTIONS, ESPECIALLY FOR BLAND INTERIORS), CHIMNEY POTS (AS UNUSUAL FLOOR LIGHTS), COLUMNS (FOR TABLE SUPPORTS), PLANTERS.

TAG SALES, ANTIQUE SHOPS, FLEA MARKETS AND AUCTIONS | FANTASTIC TREASURE TROVES. VINTAGE FABRICS, RETRO COLLECTABLES, GLASS, CHINA, FURNITURE, OLD GARDEN TOOLS, ETC. IDEAL CHEAP COLLECTION OR DISPLAY ITEMS. ANYTHING THAT IS UNIQUE AND CAN NO LONGER BE FOUND IN CONTEMPORARY SHOPS.

OFFICE FURNITURE OUTLETS, NEW AND SECONDHAND | TROLLEYS, FILING CABINETS, STORAGE UNITS, DESKS, UNUSUAL ARMCHAIRS (IDEAL FOR CLUB STYLE, ESPECIALLY FROM THE 1950S), DESK LAMPS, INDEX DRAWERS (OAK OR STEEL, IDEAL FOR INDUSTRIAL STYLE), BURNISHED METAL.

STORE FIXTURES, NEW OR SECONDHAND | CHROME RAILINGS FOR CLOTHES, COATHANGERS, ORIGINAL OAK HABERDASHER'S DRAWER UNITS WITH GLASS FRONTS (VERY CHIC IN MINIMALIST SPACES).

ETHNIC OR ALTERNATIVE CULTURE STORES AND MARKETS | FABRICS AND DECORATIVE OR HOUSEHOLD ITEMS FROM AROUND THE GLOBE.

PET SHOPS | FISH, AQUARIUMS AND ACCESSORIES.

1 MINIMALIST ART GALLERY

2 BOHEMIAN ECLECTIC

3 INDUSTRIAL CHIC

STYLE PALETTE

4 WAREHOUSE RUSTIC

5 GLOBAL STYLE

6 CLASSICAL

7 SOFT MODERNISM

THE TERM **"STYLE PALETTE"** REFERS TO THE SAMPLE CONTEMPORARY URBAN INTERIOR STYLES FEATURED IN THIS SECTION. OBVIOUSLY, THESE REPRESENT ONLY A FRACTION OF THE STYLES THAT EXIST; NONETHELESS, THIS SMALL GROUP STILL MANAGES TO ILLUSTRATE ALL THE ESSENTIAL ISSUES THAT FACE THE URBAN DWELLER—WHERE TO LIVE, WHERE TO FIND INSPIRATION, CHOICE OF DECORATION STYLE, CHOICE OF FURNITURE AND FITTINGS, USE OF SPACE AND WHICH TOUCHES WILL MAKE A HOME MORE INDIVIDUAL. THE STYLE PALETTE INTERIORS DEMONSTRATE ALL THE DIVERSITY AND RESOURCEFULNESS THAT YOU WOULD EXPECT FROM LIVING IN THE CITY, AND REFLECT THE TASTE AND LIFESTYLE OF THEIR RESPECTIVE OWNERS.

THE INTERIORS WERE CHOSEN PARTLY FOR THEIR OBVIOUS STYLE DIFFERENCES AND PARTLY FOR THE DIFFERENCES BETWEEN THE ACTUAL BUILDINGS THEY WERE FOUND IN. IN SOME CASES, INSPIRATION APPEARS TO HAVE BEEN DRAWN FROM THE BUILDING'S ARCHITECTURE, ITS PAST HISTORY, OR ITS LOCATION. THIS REINFORCES MY BELIEF THAT ONLY THROUGH URBAN DWELLING COULD MOST OF THESE EXCITING INTERIORS HAVE EVOLVED. IN THE CITY WE ENCOMPASS AND SOAK UP WHAT SURROUNDS US WHETHER WE LIKE TO THINK SO OR NOT. IT IS POSSIBLE THAT MANY ELEMENTS COULD ALSO BE FOUND IN A RURAL HOME, BUT GENERALLY THE OVERRIDING "EDGE" THAT ALL THESE INTERIORS HAVE IS COSMOPOLITANISM.

THE DECONSTRUCTION OF THESE CHOSEN STYLES WILL GIVE YOU A STARTER STYLE PALETTE FROM WHICH TO DRAW IDEAS AND INSPIRATION, AND SUGGEST WAYS OF APPROACHING YOUR OWN URBAN PROJECTS.

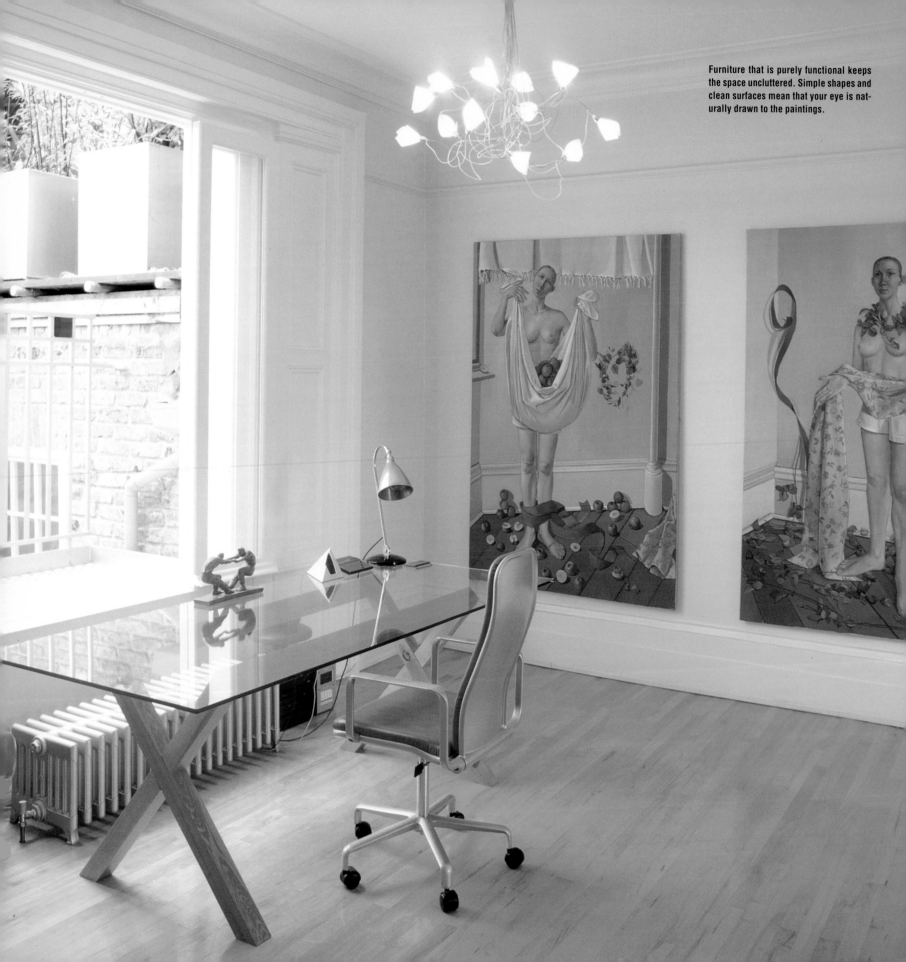

Furniture that is purely functional keeps the space uncluttered. Simple shapes and clean surfaces mean that your eye is naturally drawn to the paintings.

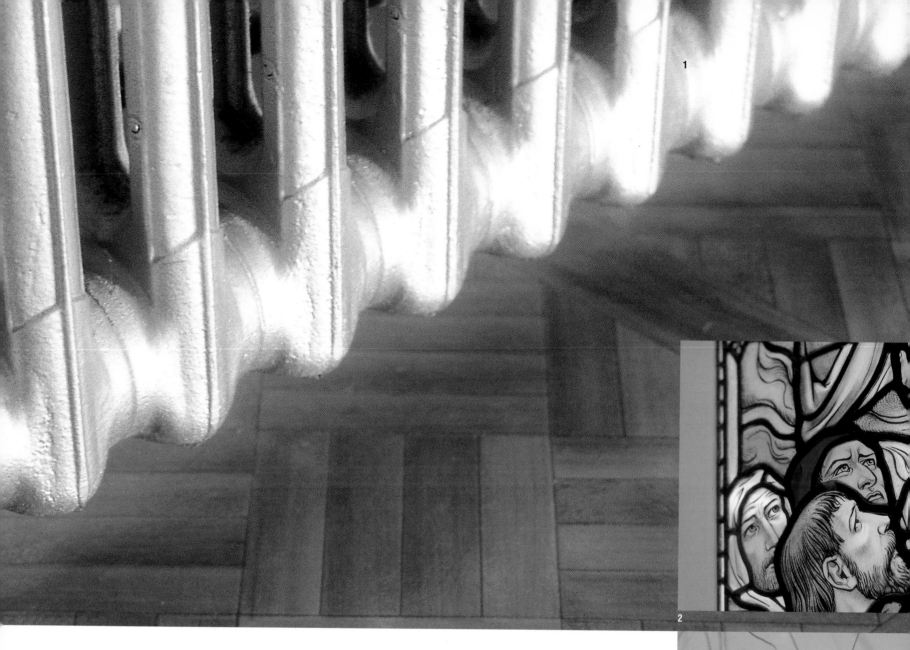

1 MINIMALIST ART GALLERY

THE ART GALLERY APPROACH IS A SPECIFIC WAY OF THINKING AS WELL AS DECORATING. IMAGINE YOURSELF AS AN ARTIST WHERE THE FIRST BRUSH STROKE YOU APPLY TO YOUR "BLANK CANVAS" INTERIOR IS AS IMPORTANT AS THE LAST; AFTER ALL, YOU WANT THE END PRODUCT TO BE YOUR OWN STUNNING, UNIQUE MASTERPIECE.

[1] Contrasting textures. The tones and pattern of this parquet flooring form the ideal backdrop for the metallic finish of an old cast-iron radiator. This style of flooring adds depth and interest to a room without overpowering it.

[2] Inspiration in the divine. The ethereal quality of stained glass panels adds a dramatic feature to a room.

[3] An electrician's nightmare, this light fixture has a wonderful ethereal quality to it. Each individual light filament can be bent and posed separately so that a unique arrangement can be created.

[1] An urban view of an urban garden. The ultra-modern interior is extended beyond the open window and into the exterior by a row of large stainless-steel troughs filled with exotic plants.

[2] Even the door is given an original treatment to add a touch of understated eccentricity. It complements another door into the same room that has a single pink-glass panel as opposed to the green one seen here.

[3] Against a plain and simple backdrop, each detail becomes distinct and a work of art in its own right. The intricacy of this piano fretwork is magnificently silhouetted in front of white walls.

[4] Everything in this interior, stripped bare of nonessentials and clutter, makes a statement. Here, the beautiful grand piano is the focal point of the room.

The first thing that strikes you as you enter this house is the feeling of spaciousness. It appears much bigger on the inside than the period façade on the outside would lead you to believe. No drastic measures have been carried out structurally on the interior, such as walls knocked out or floors removed; in fact, all the period details like baseboards, cornices and door architraving still remain. In addition, the wonderful bright and airy atmosphere has been created entirely by the predominantly white-painted walls and ceilings, alongside a very modern approach to decorating, and clever and imaginative lighting. The vast blank white walls are partly chosen for their contribution to simplicity, and partly to create the ideal gallery space for a collection of contemporary paintings. A love of art is evident everywhere. Every detail, right down to the doorknobs, has been so carefully chosen that it stands out as a work of art in its own right. This is the main reason why I have called this style of interior "art gallery."

I have also called it "minimalist," although it is not minimal in the true sense of the term. It is certainly minimalist, however, in relation to most of the other interiors featured in this book. If you are looking for an ordered lifestyle, choose functional furnishings. This interior can also be described as stylishly economical—it avoids unnecessary clutter without leaving the interior cold and heartless. Too many decorative accessories would detract from the art collection. Despite the almost monochromatic theme, there has been a passionate approach to decorating and furnishing. Each item, from light fixtures to radiators, has been lovingly considered, and obviously chosen for its interesting and unique qualities. The house extends into a garden that has also become a work of art.

For this type of art gallery look, you do not want raw urban textures but clean, light surfaces; yet avoid it becoming cold and clinical. It is important to remember at this point that the tone of the color you paint your walls can change depending on what indirect color is "bounced" back into it from elsewhere in the room. For instance, the interior would have seemed "colder" if a slate floor had been laid, because the white walls would take on blue-gray tones, whereas the white walls and ceilings are "warmed" by the ochre light reflected back up from the highly polished timber flooring.

The white walls and mellow timber flooring continue throughout most of the house, allowing your eye to flow uninterrupted in and out of rooms, further accentuating the feeling of space. You do not have to stick to white to obtain this effect; the pastel shades of Jordan almonds will work equally well, providing you choose only one. If you want to differentiate the color between rooms, vary the pastel shade you have chosen only by fractionally lighter or darker shades. Keep variations subtle, otherwise you will lose the flow-through effect.

Once you have your "blank canvas" ready, it is time to fill in the picture. Remember that great artists are often judged by their economy of strokes rather than overlaboring. Minimal decoration enables individual elements to be viewed in isolation, giving them more prominence.

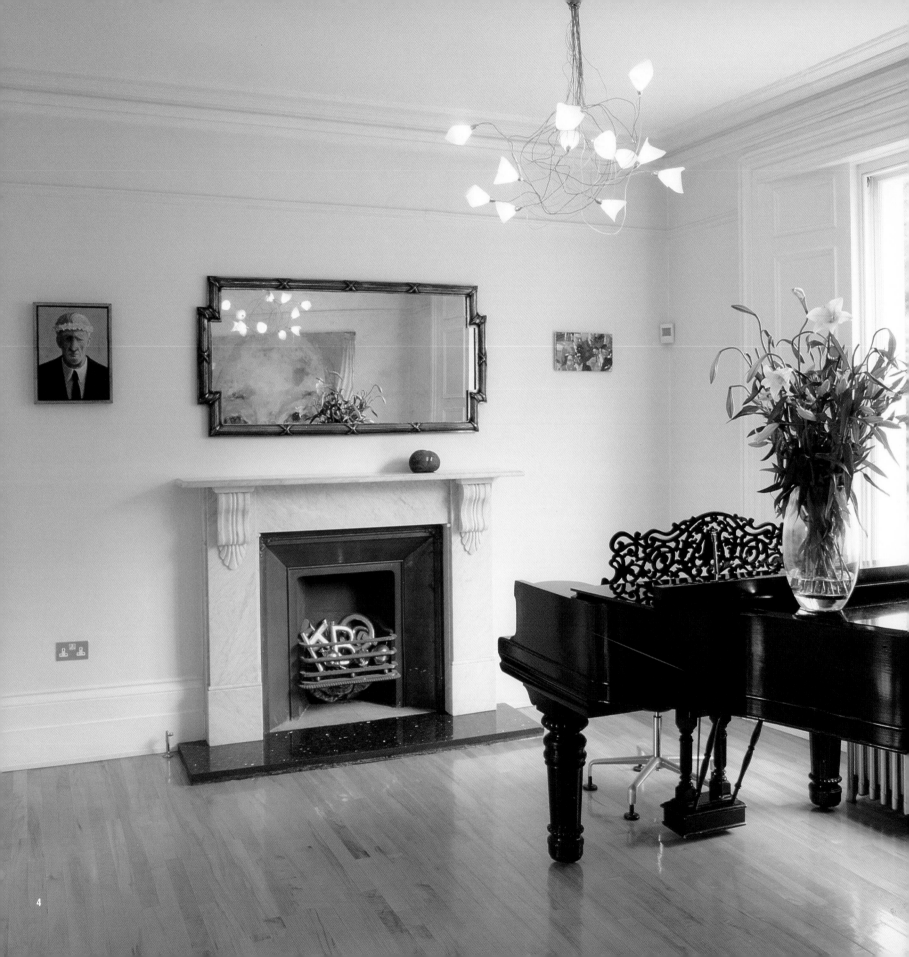

This does not necessarily mean using custom-made pieces only, but just elements that are a bit unusual or unexpected; these, when allocated to their correct position, will shine out as interesting features in a room. Seek out some of those unusual sources of inspiration in order to find that "something different."

The fabulous cast-iron window frames that originally came from a demolished factory were found in an architectural salvage yard. Incorporated into the basement room, they produce a dramatic effect. Windows are not only a functional necessity to let daylight into our homes, they are also the "picture frames" through which we view the outside world. So consider the beauty of this "picture frame" just as you would for any painting you plan to frame.

To make the most of your interior, all elements that you add should be given maximum consideration. This includes furniture, fixtures and fittings, as well as those little incidental decorative details. Although it is essentially a modern look you are striving for here, that does not mean you cannot mix a little "old" in with the "new." In the right situation, the "old" can take on a fresher, more modern look itself. It's just a case of choosing carefully. Eclectic purchases from a junk shop or flea market can be given a fine-art status just by displaying them in the right way.

Restrain yourself from shopping for too many eclectic bits and pieces, as this can spoil the effect. Clutter is not what you want for this kind of look.

Besides color and furnishings, the other key element that determines the mood of any home is lighting. This is often the least-considered detail when decorating an interior, and yet it can completely make or break the look you are hoping to achieve. The spacious, art gallery–like atmosphere of this home is successful because the lighting is such an integral part of the overall interior design. Besides the discreet halogen spotlights, which are recessed into the ceiling and work via dimmer switches, there are some very unusual styles of wall- and ceiling-mounted light fixtures. Each is unique and, like everything else in the house, takes on a work-of-art mantle. Respectfully given the right amount of space around them, they appear to float from the white walls like magical sculptures. You become so fascinated by them that you forget they are really there for a functional purpose. This is how it should be. By removing uniformity from details such as light fixtures, you lose that unattractive corporate/hotel aspect that many interior designers insist on giving homes.

[1] Two cast-iron window frames, found in an architectural salvage yard, have turned what could have been a dingy basement into a bright and airy, ocean liner–style laundry room.

[2] If you are looking for unusual features for your home, visit an architectural salvage yard. Many unique elements, such as these reclaimed window frames, can work in the most modern style of interiors.

[3] Views of the unexpected. This basement window reveals the trunks of two banana trees growing in the heart of the city. This surreal vision seems only fitting for the art gallery–style interior.

[4] Give precedence to mundane or everyday objects by allocating them a space of their own. These golden shop-front letters haphazardly arranged in the fire grate create an artistic still life for the room.

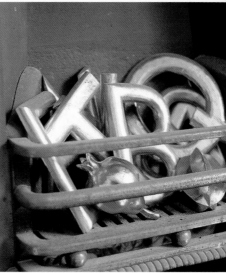

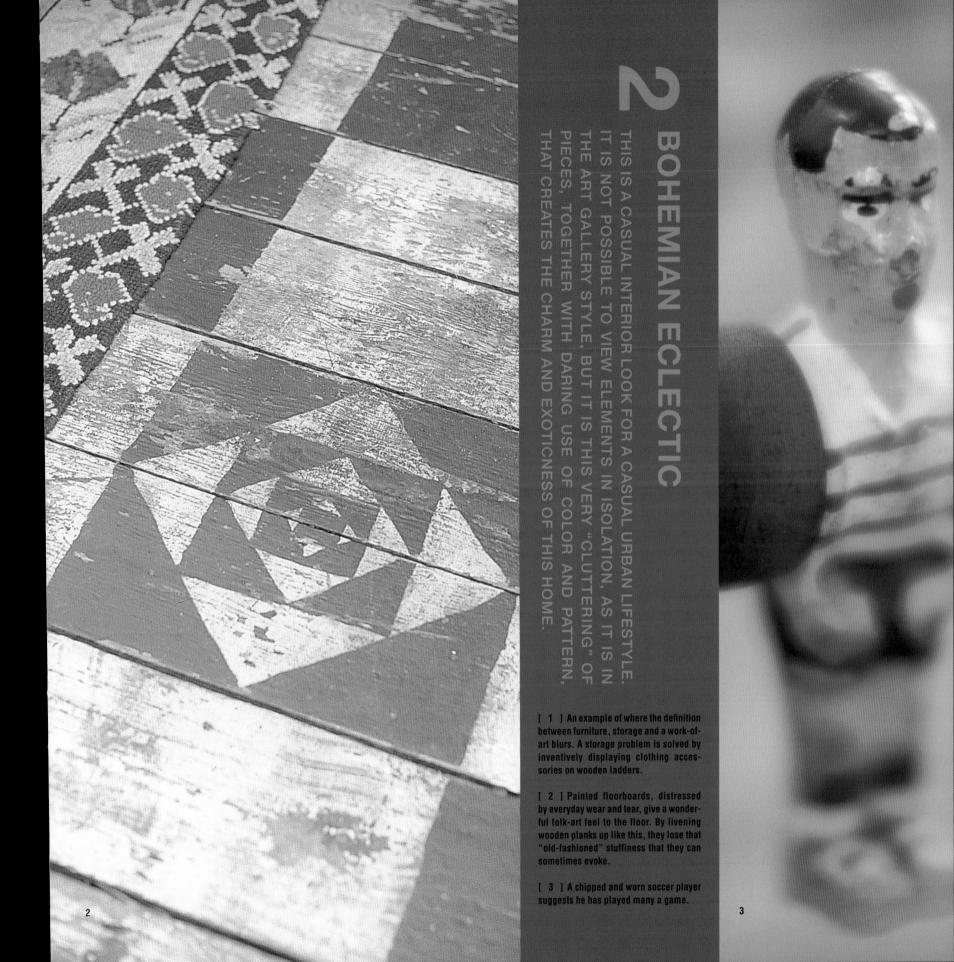

2 BOHEMIAN ECLECTIC

THIS IS A CASUAL INTERIOR LOOK FOR A CASUAL URBAN LIFESTYLE. IT IS NOT POSSIBLE TO VIEW ELEMENTS IN ISOLATION, AS IT IS IN THE ART GALLERY STYLE, BUT IT IS THIS VERY "CLUTTERING" OF PIECES, TOGETHER WITH DARING USE OF COLOR AND PATTERN, THAT CREATES THE CHARM AND EXOTICNESS OF THIS HOME.

[1] An example of where the definition between furniture, storage and a work-of-art blurs. A storage problem is solved by inventively displaying clothing accessories on wooden ladders.

[2] Painted floorboards, distressed by everyday wear and tear, give a wonderful folk-art feel to the floor. By livening wooden planks up like this, they lose that "old-fashioned" stuffiness that they can sometimes evoke.

[3] A chipped and worn soccer player suggests he has played many a game.

2

3

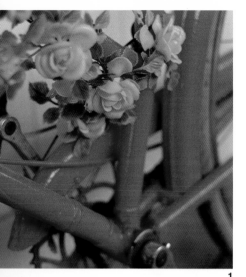

[1] Inspirational ideas for your home can be found virtually on your doorstep. This painted bicycle has been used as a prop outside the front door.

[2] A peek at the urban view through dainty muslin curtains. Besides retaining privacy, this type of sheer fabric softens the incoming daylight, giving the room a pleasant ambience.

[3] A lantern adds some oriental spice to a wall. Little details like this can be very evocative and are essential for giving a room its final flavor.

[4] The eclectic mix of old and new, checkered patterns and brash colors creates an informal and relaxed style for this living room. Notice how the room is "visually" expanded by the strategically placed mirror.

Large and airy, this studio apartment forms part of a converted townhouse situated in an early Victorian terrace with a Doric-columned portico over its front door. Like many urban dwellings, the main entrance is communal, and then each owner has another "front door" into their own private world. This is where individuality reveals itself.

This example of urban chic is relaxed and informal but never dull or unexciting. It is a wonderful mix of rich, bold colors and patterns and an intriguing collection of eclectic furniture. It contains decorative items from around the world, melding exotic elements, simplistic folk-art designs, kitsch and pop art with romantic feminine touches to create a very individual and distinct style I have called "Bohemian eclectic."

It is what I would describe as the pick 'n' mix approach to interior decorating—a little bit of this with a little bit of that, following no design strategy other than choosing what you instinctively like or feel passionate about. Despite being drawn from such diverse sources, the overall look works well. Everything has meshed together to turn an urban home into a cozy haven. Your first instinct on entering this apartment would probably be to head straight for the luscious sofa and slump into it. This is how relaxed and welcoming this style of interior can be.

Part of the success is due to the sheer muslin drapes that hang permanently down in front of the tall balcony windows. They separate the inside from the outside, which is an important aspect for urban living. In this interior, you are not aware of the weather outside, nor what external view lies beyond the drapes, but instead are fully aware of the wonderfully soft daylight filtering through the fabric. It makes the room seem quite timeless. Using light and floaty fabrics at your windows will create a romantic, dreamy feeling.

Keep walls fairly light in color, especially if you have limited space. However, in a studio apartment with high ceilings you could quite easily have a deeper color on the walls.

Use the wall areas to display your bought and found objects, paintings, prints, mirrors and even collections of clothing accessories, but do not obliterate the wall as though it were a giant pin board. Leave spaces, and group together objects and pictures with similar themes. These collections can help differentiate areas within the room by drawing your attention from one pocket of interest to another.

Try to find space on at least one wall for a large mirror—the larger the better. The reflection in this of another part of the room will give the illusion of extra space. Floor-to-ceiling mirrors are best in this case.

Because the walls are painted in a single color, the floor design in this studio apartment works particularly well. The checkerboard design painted on the floor not only gives the room a nice textured quality but also adds a sense of humor to the room. It is rather like a giant chessboard, and instead of chess pieces standing on it there are diverse pieces of furniture ranging from a bright red vinyl armchair to a soccer game table and an armoire with no doors. The border painted around the outside edge of the

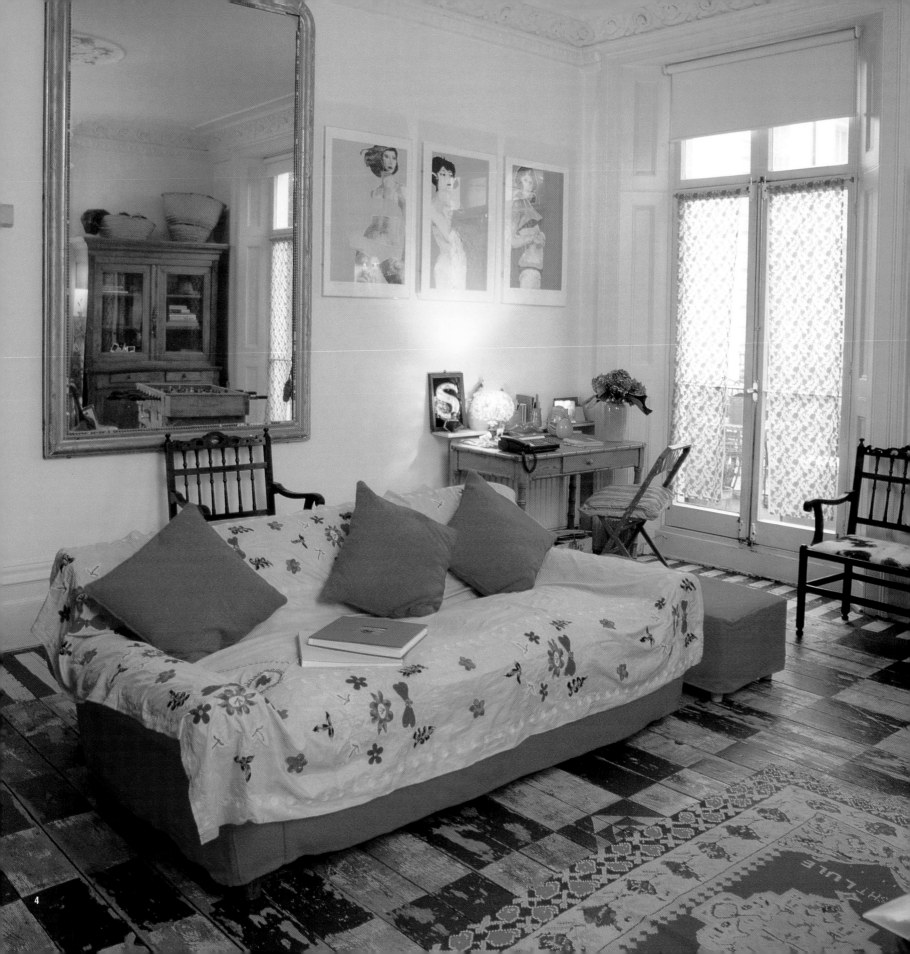

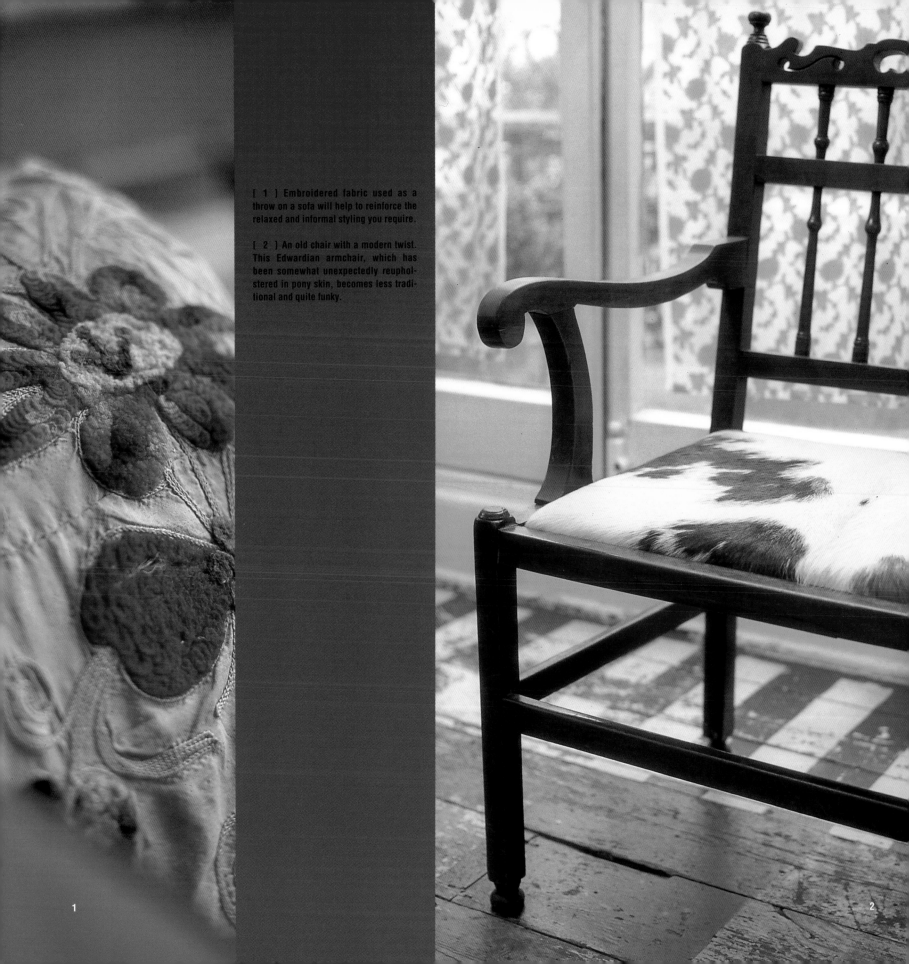

[1] Embroidered fabric used as a throw on a sofa will help to reinforce the relaxed and informal styling you require.

[2] An old chair with a modern twist. This Edwardian armchair, which has been somewhat unexpectedly reupholstered in pony skin, becomes less traditional and quite funky.

1

2

room conjures up images of something between a Dr. Seuss landscape and the classic design of a hatbox.

As an alternative to painting floorboards, try staining them in a bright color. Floor stains are now available in a good range of colors, and these have the advantage over floor paint in that you can still see the wood grain. Scatter rugs here and there on top of the floorboards to continue the theme of informality. The impression you want to achieve in a room like this is that nothing seems too precious or out of bounds, as this is ultimately what makes this style so comfortable to live with.

When it comes to furnishing the Bohemian way, there are no hard-and-fast rules. It is the mix 'n' match approach. You can mix old with new, as long as the modern pieces have character. In fact, this holds true for everything in the household—crockery, cutlery, linen, lamp fixtures and so on. As far as furniture is concerned, however, you want pieces that have a romantic quality to them—for example, through distressed paintwork, knobbly legs or plush fabrics, rather than pieces that are cold, superstreamlined and emotionless.

Customize old chairs with exotic covers and give them a refreshing new lease on life. Look out for sumptuous fabrics like velvet and silk, and textured ones with glass beading, embroidery and appliqué. Avoid getting caught in a narrow mind-set of what you think you should and should not do with antique furniture.

If you own an old chair that looks too dark and heavy for your room, give it a coat of paint in celadon, white, or your favorite muted color. Jazz up that dark brocaded seat with some folk-art chintz or fun fur. I am not suggesting that you do this to a piece of Chippendale or similar priceless antique. Stick to customizing less expensive junk-shop or flea-market finds. Alternatively, for a less drastic revamp, cover pieces of furniture in a fabric of your choice in the form of a throw, or add cushions covered in a racy color. Remember, though, that the clever, haphazard look you are seeking could turn into a hotchpotch if you do not keep your colors complementary or maintain an overriding color theme throughout.

This apartment has splashes of pink everywhere, ranging from deep fuchsia to pale bubblegum, which both complement the black-and-white floor and tie all the other colors together.

Keep artificial lighting soft and ambient. It is far better to have an abundance of table and wall lamps than an overpowering main source from above. Bright overhead lighting will kill any romantic ambience you want in the room, as well as flatten subtle colors and furnishing details. Objects are only three-dimensional when they are defined or "sculpted" by light, so an excessively bright overhead light, such as fluorescent striplights, will flood out definition, rather like a camera flashbulb does. Instead, choose wall lights with dainty beaded or printed-card lampshades. Turn these into focal points by hanging pictures or mirrors beneath them so that they are illuminated from above. Give them a further Bohemian look by customizing them with trinkets and momentoes, particularly pieces that are translucent or refract light.

3

4

[3] Walls double up as storage space for handbags. If you have an attractive collection of clothing accessories, flaunt them rather than hide them. Displayed well, there is no reason why they cannot be considered part of the furnishings.

[4] A quirky junk-shop find like this table-soccer game is not only entertaining for your guests but a great piece of eclectic furniture in its own right.

[5] Customizing a light fixture with beads and mementoes makes it more personal. A clever arrangement like this creates a pleasing pocket of interest within the room.

5

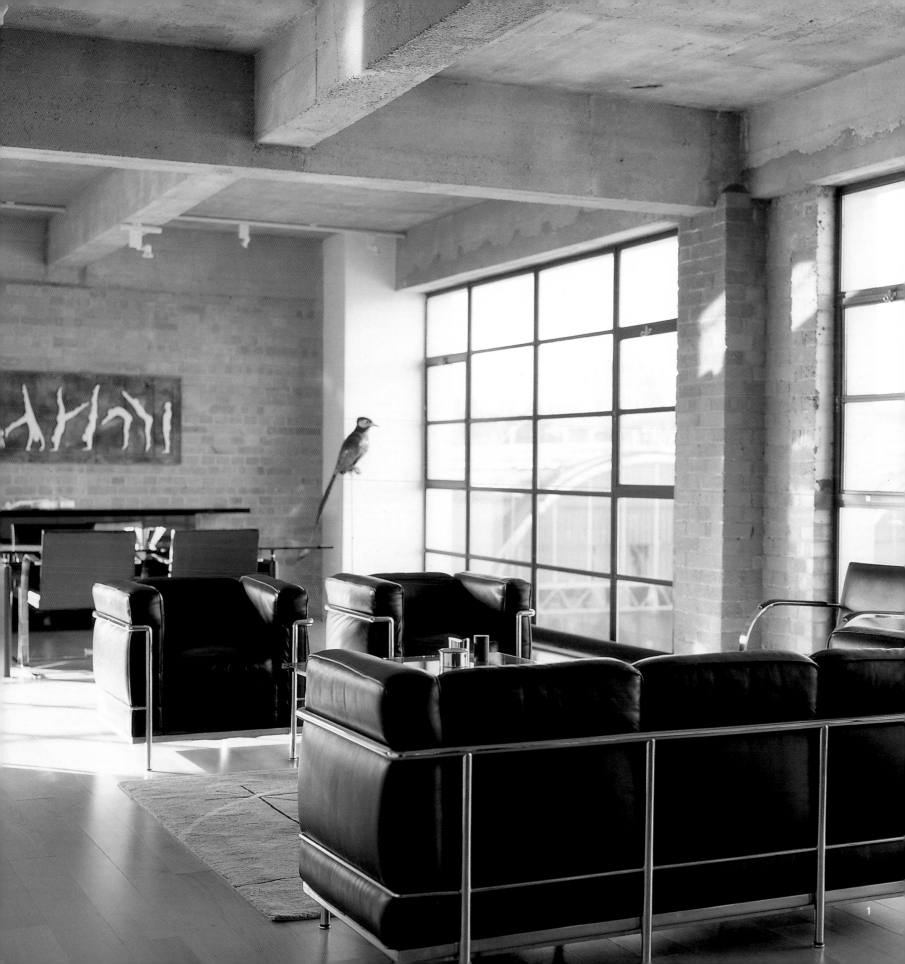

[1] There is no shortage of daylight in this industrial-style loft apartment. Notice how the geometric lines of the Le Corbusier sofa reflect the geometry of the steel window frames.

[2] Built with large-scale proportions for their original function and practical purposes, industrial spaces often dwarf surrounding domestic properties. This provides the opportunity for panoramic views over the city.

2

3 INDUSTRIAL CHI

INDUSTRIAL-STYLE LOFT SPACES ARE THE "WIDE-OPEN PRAIRIES" OF URBAN DWELLINGS. OPEN-PLAN LAYOUTS, WHEREBY ONE DESIGNATED AREA SPILLS OVER TO ANOTHER WITH LITTLE OR NO DIVISION BETWEEN THEM, MAXIMIZE THE AVAILABLE DAYLIGHT AND CREATE AN INFORMAL INTERIOR STYLE THAT IS COMFORTABLE AND RELAXED.

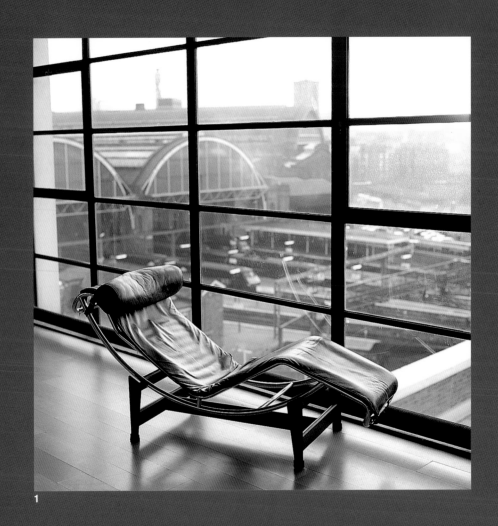

1

Once, not so long ago, living close to a railroad or subway would have been considered undesirable, but times and public stigmas have changed radically. Now it is desirable to live among the "gritty" landscaping that personifies urban living. This is due in part to the new nonconforming pioneering spirit of urban living that has emerged over the last 10 to 15 years. Today, urban dwellers actively seek out industrial- and commercial-style properties in which to set up home. These nondomestic, large, open spaces are generically known as lofts.

The idea of loft-living originated in the 1970s in New York. Artists seeking inexpensive, large spaces in which to work and live started moving into redundant industrial factories and warehouses on Manhattan's Lower East Side. The main virtue of this type of urban architecture was the generous amount of light and acres of uninterrupted open internal space.

The novelty of living in a New York–style loft apartment later caught on in other parts of the world, and today it has become so fashionable that brand-new blocks of apartments are being custom-built and advertised as "loft apartments" to cope with demand. Although the slightly radical and subversive nature of lofts, which came from the image of artists living and working in them in Manhattan, has been lost on these new gentrified versions, many conversions in old buildings still maintain this feel. Try to find a conversion in an authentic commercial property, as this will have the original features that help set the tone from the start.

The apartment featured here is a good example. It has all the gritty industrial qualities you would expect, being based within a beautiful, old Art Deco factory situation a stone's throw from a city subway. The location is a good example of urban regeneration, whereby rundown and underrated city fringes are now being turned into trendy and desirable residential areas.

Since industrial spaces like this were never originally compartmentalized into bathrooms, bedrooms and kitchens, they lend themselves to a less-regimented style of living from the start. This type of apartment is certainly the antithesis of the rather claustrophobic examples normally associated with urban living.

The main features of this apartment are the huge steel factory windows that dominate the main sitting area, and which continue around the two other external walls, the bare internal brickwork, the concrete ceiling and the polished timber flooring that travels throughout the apartment. Advantage has been taken of the actual structural fabric of the building, which has become the predominant decoration within the apartment. It is important to feature and retain architectural details as much as possible in order to give character to your home. Cover them up and you may as well live in a brand-new custom-built loft apartment. Instead, allow these raw materials to become the backdrop against which everything else must be made to work.

Bare brick walls have plenty of texture and subtle variations in low-key color tones. Let this be your wallpaper. Do not cover it with too much clutter—just the occasional picture or print, ideally bold and dramatic examples, as they will be competing

2

[1] The nearby railway station forms a fitting backdrop for the Le Corbusier chaise longue. The station was designed during the 1920s when architects and designers looked towards the machine age for their inspiration.

[2] The concrete structure of this factory ceiling has been left exposed. Try to leave original features like this exposed to maintain a gritty, urban feel.

[3] Just a small fragment of the city's fabric can provide a great wealth of inspirational material for an industrial-style interior. This wall displays three distinct textural qualities and a palette of complementary colors from which to draw ideas.

[4] Find inspiration from industrial materials used every day in the city. When you spot something you like, make notes on its color, texture and form. Ideally, take a photograph as a permanent reference.

3

4

[1] Glass bricks offer the ideal solution for dividing up large industrial-sized spaces without losing valuable daylight. Originally designed for external use on buildings for letting light into communal stairwells, they automatically bring their intrinsic industrial qualities indoors when used as partition walls.

[2] Looking more like a cooling stack from an Art Deco power station, this floor-mounted radiator is a perfectly chosen detail for this style of apartment. Look for suppliers who deal mainly with factories and light industry to find similar details not normally seen in the domestic market.

for attention against a "busy" brick wall. If you want to incorporate bare brick walls in your home, make sure they are properly sealed, or you will be forever finding a layer of grit and sand on all your books and surfaces. If you do not like the look of bare bricks, you can always paint over them in white or a pale color. The fact that you will still see the lumps and bumps defining the brickwork beneath the paint will provide enough clues as to the wall's industrial past.

To enhance the existing materials, incorporate other nondomestic-looking materials, such as glass bricks. These offer one of the best solutions for dividing up

1

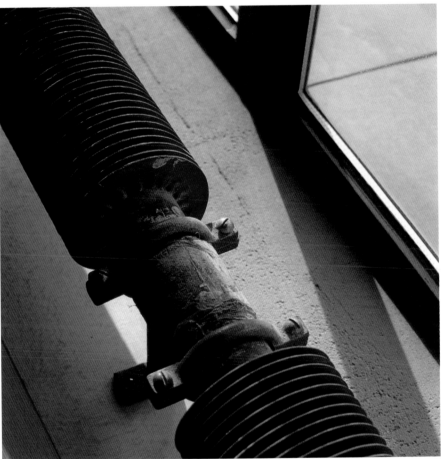

2

large industrial spaces while maintaining a minimum loss of available daylight. Other details, such as radiators, light fixtures and work surfaces, have all been chosen for their simplistic and functional qualities. To find similar materials and details, seek out suppliers of nondomestic materials in catalogues or trade magazines mainly aimed at architects and the building industry. Visit builder's supply yards and just look around, remembering to have that "alternative approach" in your mind all the time.

The color palette used here has been created primarily from the industrial materials within the apartment, with the addition of black leather furniture, pure white internal paneled walls and frosted plate glass in the shower. So it is mainly

a palette limited to green-grays, steel grays, black, white, charcoal, terra-cotta and ochre—colors that reflect those we are familiar with in the urban environment.

An exciting aspect of this loft apartment is its distinct and almost overwhelming geometry. The inherent lines of the apartment's structure, such as the vertical and horizontal lines of the steel window frames, the right-angled intersections of the concrete ceiling lintels, and the stacked, cubist glass bricks, are emphasized by the introduction of a complementary style of furniture. Furniture in the "Modernist" or "Bauhaus" style is extremely appropriate, not only because of the geometry aspect but

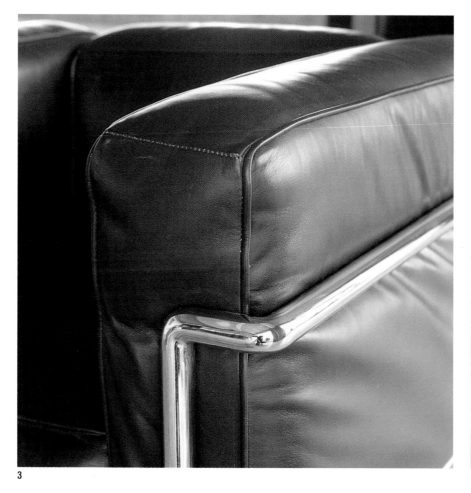

3

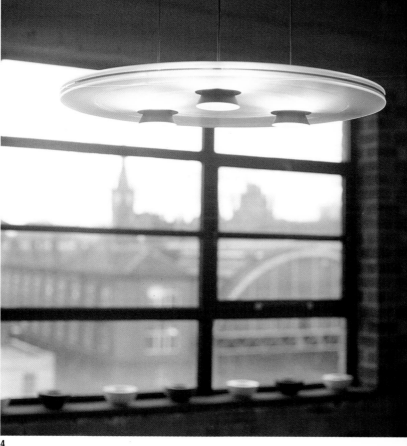

4

also because of the very purpose for which the building was originally intended. In the early part of the twentieth century, factories represented the epitome of the machine age, where machines were perceived as great symbols of power and progress. This inspired architects and designers in the 1920s to abstract this ethos into their designs for buildings and furniture. They combined the latest man-made materials of the time, such as tubular steel, with natural materials, such as leather, to create bold, dynamic pieces with strong sculptural qualities. Furniture designs by Le Corbusier, Mies van der Rohe and Marcel Breuer have become such design classics that they are still produced today.

[3] Pure geometry. Originally designed in 1928 by the architect Le Corbusier, this chair was a "Modernist" interpretation of the traditional club armchair. It was a revolutionary piece of furniture owing to its steel structure being externalized and featured outside the leather cushions. It is still being manufactured today.

[4] Somewhat reminiscent of a suspended factory light fixture, but with definitely far more futuristic overtones, within this fixture the light from the three individual sources is diffused across the surface of a circular plate of glass, allowing for a larger and more even spread of light over the table beneath it.

Here, examples of design classics serve the space well, making it coherent and tight. However, its rigidity, created by its angular shapes and hard surfaces, may not be for everyone. If you want to soften the look slightly, use brown leather furniture with ample curves and rolling sides instead of the black leather and chrome. For a more informal arrangement to the furniture, try placing a battered brown leather chesterfield and accompanying armchairs around the periphery of an old rug, the more threadbare the better, with a low, wooden table as its focal point. Add details like placing a 1930s wooden standard lamp at the side of one of the chairs. This fireside arrangement as an island in the center of an open-plan industrial space will give the necessary relaxed informality but with an anarchic twist—a warm, traditional touch within a very fresh and contemporary shell.

If you want to create the industrial chic look but are wanting to furnish on a limited budget, start foraging at secondhand office furniture stores and auction houses that specialize in office clearances. You can pick up some stylish bargains. Look out for plush leather boardroom chairs and generously sized teak desks. This could fulfill all your dining-room requirements. Corporate reception-room coffee tables might be just right for the comfortable sitting area of your space.

More unusual items, a wheeled cart for example, could provide a quirky addition when used in an imaginative and creative way. There is no shortage of secondhand, steel filing cabinets, which can be burnished to remove their old paint-work and brought up to a handsome metallic finish. These are relatively inexpensive and make excellent storage drawers in kitchens, bathrooms and living areas for everything from bed linen to toys, as well as giving your home an unmistakable stamp of the industrial. Also keep a lookout at secondhand office furniture stores for interesting lamps and light fixtures. Desk lamps come in all shapes, sizes and finishes from heavy brass, flexible-stem lamps to the classic counterbalanced Tizio lamp. Like many pieces of office furniture, lamps often have great design names behind them, eventually turning them into collectables. Some of these, even from the late 1970s and early 1980s, are attracting auction-house prices. Look out for similar, well-designed examples that are not as sought-after. These might even end up being a collectable in the future.

Lighting in an industrial-style apartment should be discreet so as not to detract from the internal architecture. You should be able to see what you are doing without being aware of the light itself, so make sure that strong light sources are secreted behind lintels and recessed into ceilings. The one feature you don't want for your loft-style home is authentic industrial lighting.

1

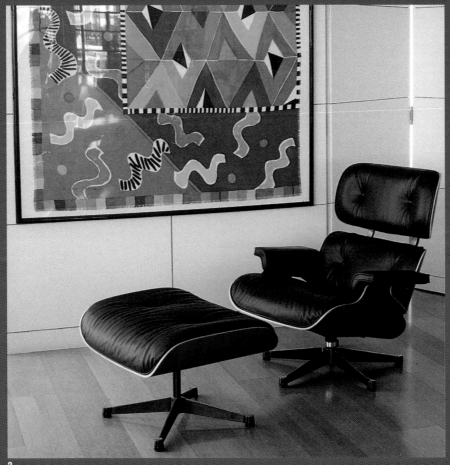

2

[1] By incorporating ceramic shapes
for the gas flames to dance around, more
interest has been added to an otherwise
minimalist fireplace.

[2] The lounge chair and ottoman
designed in 1956 by Charles Eames has
become a much-sought-after furniture
classic of the twentieth century. It influ-
enced Italian-designed office furniture,
some of which has also become very
collectable.

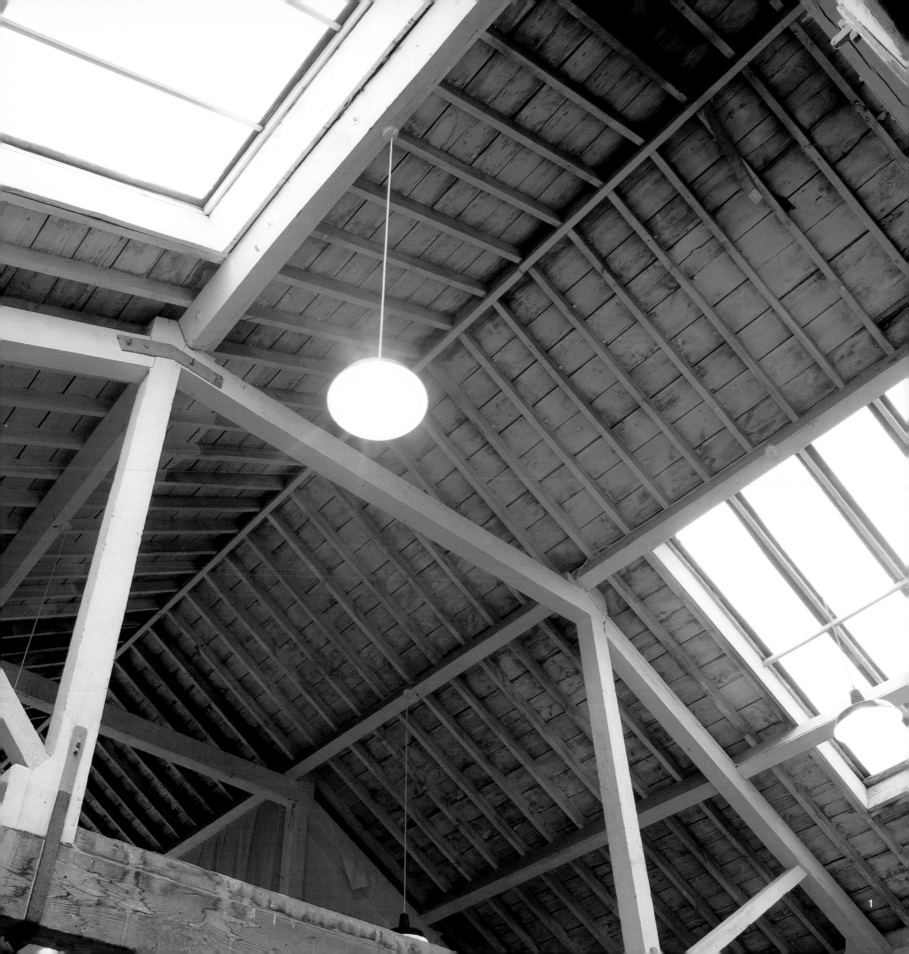

[1] Industrial-sized skylights help provide the ground floor with ample daylight. It is elements like this magnificently constructed roof that make commercial properties so attractive to live in.

[2] Once you have decided on the theme of your interior style, you can start having fun tracking down objects and materials that are appropriate and will help portray your vision. This ship's wheel found in a salvage yard would make a fitting seafaring feature for any riverside apartment.

[3] Only by overlooking a river or park can you find such breathing space between buildings. Riverside homes can provide a welcomed and relaxed escape from the stresses and strains of urban life.

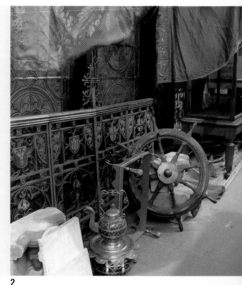
2

4 WAREHOUSE RUSTIC

WITH THIS STYLE, YOU ALMOST FEEL AS IF YOU ARE GENUINELY LIVING IN AN OLD WAREHOUSE. THE INTERIOR RETAINS ITS ORIGINAL, FABULOUS FEELING OF SPACE AND LIGHT AND IS FURNISHED IN A CASUAL, ECLECTIC WAY.

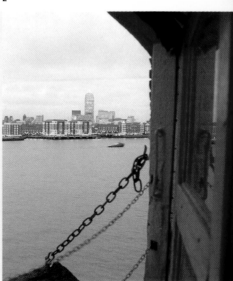
3

Continuing with the loft theme, this apartment is situated on the top floor of a Victorian pepper warehouse. In many ways, it is much closer in spirit to the original artists' lofts in New York than the apartment in the previous section, not because of the different architectural styles of the properties but because of the differences in decoration and furniture. This apartment has been furnished in a casual, Bohemian way. An eclectic, rough-and-ready approach has been chosen rather than a more finished and orderly interior scheme. Perhaps this is partially due to the different location—next to a river rather than a railway station. Each location represents a distinct pattern of urban life.

In a bygone age, rivers were the arteries of the world, the aquatic highways on which ships bought, sold and traded all manner of essential goods—foods, spices, silks, porcelains, and of course raw building materials—to expand the urban landscape. Warehouse storage was an essential part of this process. When the development of road haulage more or less killed off river transport, most of these warehouses became redundant. Only in recent years, as the vogue for alternative living spaces has caught on, have these buildings found a new purpose.

This apartment exemplifies an alternative living space. Housed in a stout, brick building, it has large loading-bay doors that open up to reveal a breath-taking view across the river. The interior is unique, and is the result of the owner's initial great empathy with the building, along with the natural evolution of ideas over the years while living and working there. Its well worn and weathered look has been retained and the unobtrusive interior design involved minimum structural change.

In many respects, this approach is similar to that of the industrial chic apartment in the last section, even though the two final looks are completely different. They have both complemented and harmonized their interior ideas with the actual architecture of their spaces, allowing the aesthetics of the inherent materials to shine through. Wallpaper has no place in loft-living—a pail of whitewash should be as far as you go.

Here the interior backdrop consists of exposed brickwork, the original mellow-colored maple flooring, and an expansive timber roof structure that has not been repainted but left in its grubby, aged-looking state.

The inspiration for the apartment has come predominantly from the warehouse's past history and its prominent location by the river. Water naturally conjures up a nautical theme, with visions of beach huts, lifeguard towers, ship's galleys, boat decking and all other sailing paraphernalia from ropes, buoys and flags to life preservers and lanterns.

This does not mean the result is a Popeye-style theme-park extravaganza—far from it. The achieved look is a cross between a salty sea-dog's whaling shack and a touch of "California beach house." It is a clever fusion of found materials, architectural salvage, junk-shop and dumpster finds that creates an environment with a feel that is a million miles from the hard and abrasive equivalent of city life.

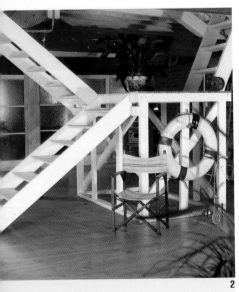

[1] An original item from the warehouse's past adds an authentic touch. These Victorian cast-iron weighing scales were retrieved from a dumpster after being thrown out during refurbishment of the building's basement area.

[2] The skeletal design of this staircase and landing is easily likened to a lifeguard's lookout tower at the seaside, especially with the addition of a life preserver and deckchair.

[3] The rustic charm of this sitting-room area is achieved by blending the original timbers and exposed brickwork with a mix of furnishings that possess similar weathered and worn attributes. The walls that define this space have all been made up from salvaged glass-paneled doors.

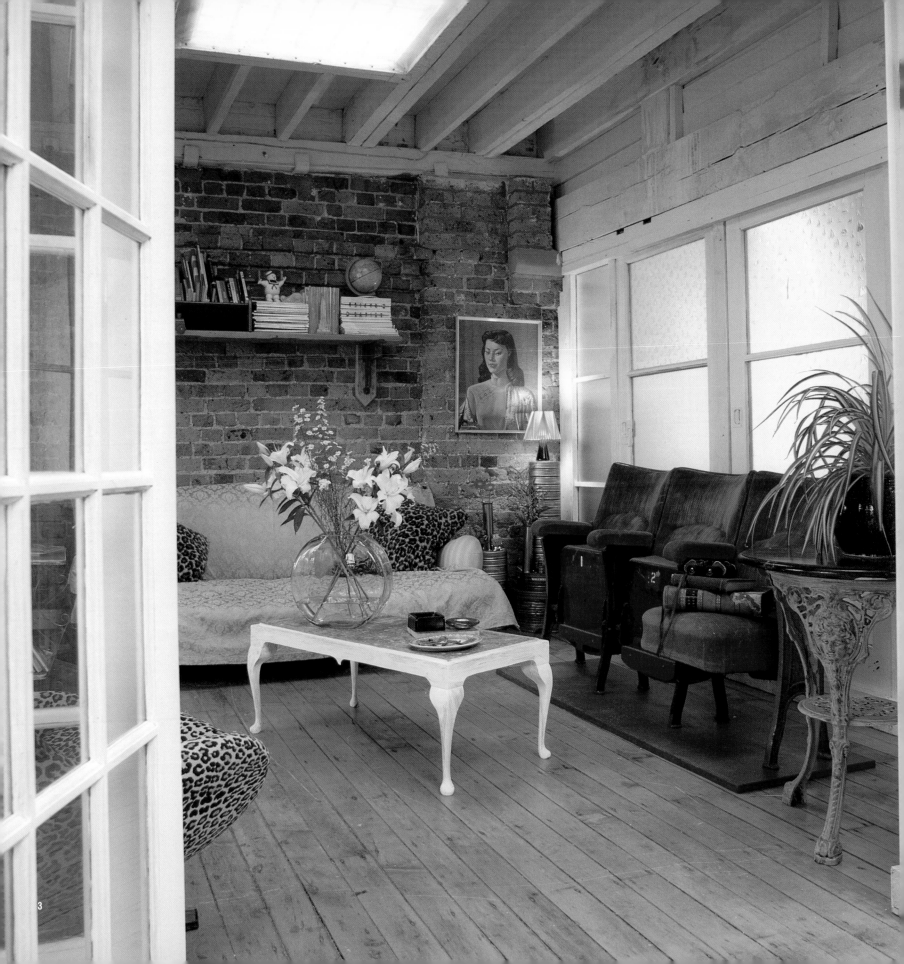

[1] Treasure from the deep—a fascinating still-life composed of detritus scavenged from the riverbed at low tide. Found objects all have a story to tell that no downtown purchase could muster. Arrange and display your finds—they will make intriguing conversation pieces.

[2] A small row of cinema seats helps to establish the eclectic tone of the interior.

[3] The nautical inspiration for the overlapping planking used on the sides of the bar area came from the apparent construction of seaside beach huts and boat hulls. The cabinets beneath the sink area mimic this look with louvered doors.

[4] An alternative use for old steel and cast-iron window frames is to turn them into internal walls or room dividers. These were salvaged from a Victorian factory that was being demolished. The original rusty paintwork has been kept intact as a feature.

[5] A junk-shop find hangs high up among the ceiling timbers. Although somewhat macabre, the deer antlers complement the bleached planks and embellish the antiquated mood of the apartment.

[6] Magazines are arranged on a shelf in such a way as to enable other objects to occupy the same space. Mementoes from childhood add a personal touch to this sitting room.

Where new materials have been introduced, they are limited to reclaimed timber and salvaged elements so that the interior looks as little interfered with as possible. One of the most successful elements introduced into the space was the solution found for the kitchen and bathroom areas. Solid walls were needed for these particular rooms, but it would have been undesirable to make them appear as if they had just been plonked obtrusively within the empty space. Instead of using uninteresting flat sheets of sheetrock for the partitions, timber partition frames were clad with tapered planks normally used for sheds and outhouses. The overlapping or clapboard effect of this gives an instant beach-hut look, especially after a coat of white or pastel-colored emulsion paint.

You could enhance the timber cladding with a weathered look by painting over your first coat of emulsion, once it has dried, with a watered-down pale to mid-gray color, wiping off the excess with a cloth before it dries. This will leave a residue of the darker shade in the cracks and knots of the wood, artificially "aging" the paintwork.

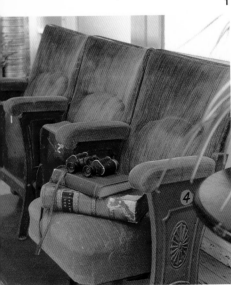

1

2

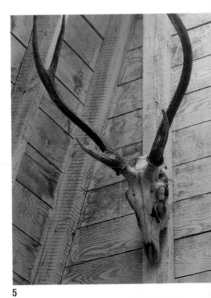

3

4

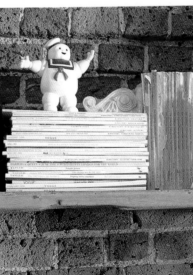

5

6

Of course touches like this clapboarding can be added to your home even if you do not live in a loft apartment. Remember that your interior can be your escape from the rigors of the exterior urban environment, and with a little imagination it can be anything you want it to be whether you live in a small townhouse or a high-rise apartment. Nor does it have to be expensive: shed cladding can be found at most lumberyards and if you choose the unplaned variety, which has a rougher surface, it will cost very little to cover domestic-sized walls.

Another relatively inexpensive trick, which also adds lots of character to the space, is the use of old windows, or glass-paneled doors, as partition walls. Besides their characterful appeal, their extra benefit is in allowing light to pass through them so that space can be divided without making it dark and claustrophobic.

The cost of materials for this kind of project depends entirely on how resourceful you are. It often requires you to think innovatively on the spur of the moment in order to take advantage of an opportunity. For instance, renovation of industrial or commercial properties in the city can often mean the replacement of original steel windows by more practical, double-glazed equivalents. Seize the moment, and ask the site foreman if you can have the old ones. More often than not you will get them, as they would only be dumped otherwise. They may no longer be suitable for exterior use, but they will be fine to turn into interior partition walls. Broken panes can easily be replaced.

This apartment has been furnished entirely with junk-style furniture. Some were lucky finds; others were carefully chosen from flea markets, tag sales and antique warehouses. This produces a mood of romantic nostalgia that, because of the eclectic choice of pieces, does not appear stuffy or old-fashioned. The amalgamation of fun fur with brocades, French candelabras with 1950s goose-neck lamps, and kitsch prints with old enamel advertisements exemplifies the contemporary essence of urban living. By similarly mixing different styles and eras you too can originate a unique look. If you do it well, it will not become dated. Do not be too serious in your choice of furnishing, and allow a sense of humor to enter it.

To maintain the character and mood of such a fantastic space choose unusual light fixtures. If you want to incorporate state-of-the-art lighting, try to keep it discreet (see Industrial Chic, page 37), so that you do not spoil the ambience. Look for lamps and shades that are sympathetic to your style of home. Specialty lighting shops now reproduce all types of period fixtures from Art Deco ceiling lights to Victorian oil lamps. If their "newness" worries you, you can always revamp them with paint, steel wool or brass-dulling lotions. In this way, you can create fixtures that are safe but have a finish that best suits your rustic home.

To appreciate fully the textural beauty of your loft apartment, try using candlelight. Embellish your dining table with a Bohemian assortment of candleholders, even if they are only Chianti bottles. Ultimately, a laissez-faire approach is far more chic than an overly fastidious one for this style of urban dwelling.

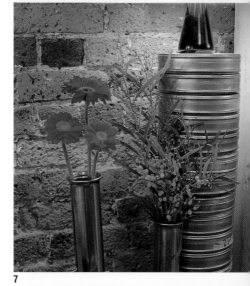

[7] An inspired use of materials. Stacked film cans become plinths for a collection of toys, flower arrangements and table lamps. The flower vases are made from portions of an old car exhaust that had been dumped in the river.

[8] Original enamel factory lampshades maintain the nostalgic quality of the interior. Although similar modern equivalents can be bought in downtown stores, these authentic ones came from an architectural salvage yard.

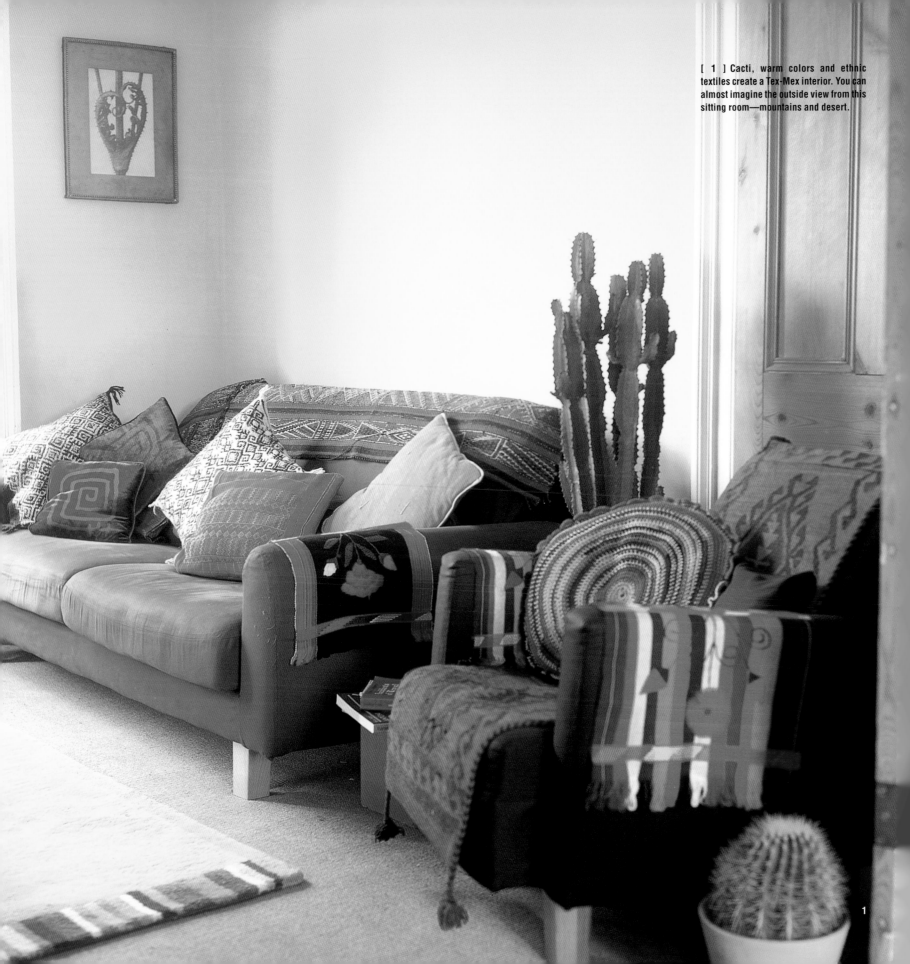

1

5 GLOBAL STYLE

YOU CAN EASILY RE-CREATE ANOTHER
CORNER OF THE WORLD IN YOUR OWN
HOME, WHETHER TO REMIND YOU OF A
MUCH-LOVED TRAVEL DESTINATION OR
TO FULFILL AN EXOTIC FANTASY. ALL
YOU NEED ARE A GOOD SOURCE OF
INSPIRATION AND A VIVID IMAGINATION.

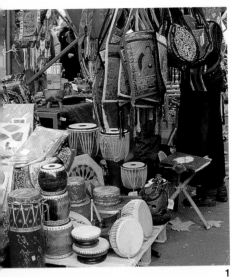

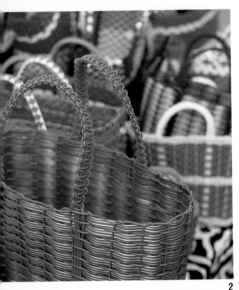

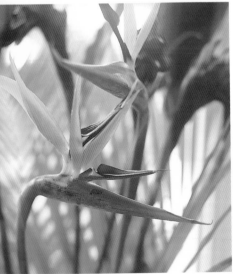

[1] The lively display of bongos and bags on this market stall has a distinct Moroccan bazaar quality to it. Seek out decorative items in your own city markets that will complement your chosen interior nationality.

[2] Authentic Mexican household goods such as these plastic shopping baskets are always bright and cheery, and will add a brave dash of color to your decorating scheme.

[3] Exotic plants and flowers are an essential addition to evoke an authentic feel. "Birds of paradise" flowerheads look as if they have come straight out of a painting by Mexican artist Frida Kahlo.

[4] The bold use of color and the addition of a religious icon has transformed a traditional fire grate into an eye-catching, shrine-like centerpiece.

Our homes are the nests we fly back to after a hard day at work or a busy day of shopping. Sometimes home is the place we long to return to after a long expedition or vacation abroad. For all our desires of wanting to get away from it all, most of us still return with a sigh of relief and say, "It's good to be home again." Home itself, however, can be that foreign escape, whether it is because we want to prolong that feeling of warmth and exoticness experienced on vacation or just because we have an overwhelming desire to live another country's culture and style.

Here two distinct global styles—Mexican and Moroccan—have been incorporated into a small Victorian terraced house. When abroad, absorb the essence of different cultures and bring back ideas and objects to contribute to the transformation of your home. Whether your global inspiration comes from foreign journeys or from exhibitions, books and magazines, there are always key ingredients to take note of: color, textiles, ornament design and furnishing accessories.

The strongest and most immediate of these is color. Most countries or cultures can be associated with a specific range of colors. It is a color palette that originates from a combination of the country's climate, culture, religion, traditional crafts and inherited customs. It can even be based on sources of natural pigment, such as plants and minerals. In some countries, color is given immense importance, far greater than merely a palette for interiors. Color can symbolize class, wealth, status, royalty, tribal divisions and lines of ancestry.

As a general rule, areas with hotter climates, such as India, South America, the Caribbean, the Mediterranean and North Africa, have brighter, more intense colors, while northern countries, such as Norway, Sweden and Russia, have more conservative pastel and gray ranges. Mexican and Moroccan themes equate with hot and vibrant colors. Bold colors can be used in everything from kitchen crockery and bathroom tiles to rugs, throws and even furniture.

Once you have worked out the colors for your chosen global style, the next thing is to know how to use them. It seems obvious, but different cultures have different approaches to how they use color. For instance, a Mexican interior is not limited to two colors, one for the walls and one for the woodwork. It can have as many as six or more colors, each wall a shade of its own, and doors and doorframes likewise.

If you want your global interior to look authentic, you will also have to consider the quality of your walls before you paint them. Yours may be perfect with a smooth surface and crisp, neat edges, whereas in North Africa or South America, owing to limited or homemade building materials, finishes are usually more crude and rustic. You might want to consider having your walls replastered with a grainier mixture that is not smoothed out flat. When it dries, you will be left with a rougher, more uneven texture, which when painted will give you the rustic look you are after. Alternatively, you might want to cover your walls with an unusual material or fabric. Hang rugs and kilims on them for an intimate Moroccan feel; or, for the ultimate global transformation to your interior, cover your walls with lengths of bamboo or woven palm leaves for

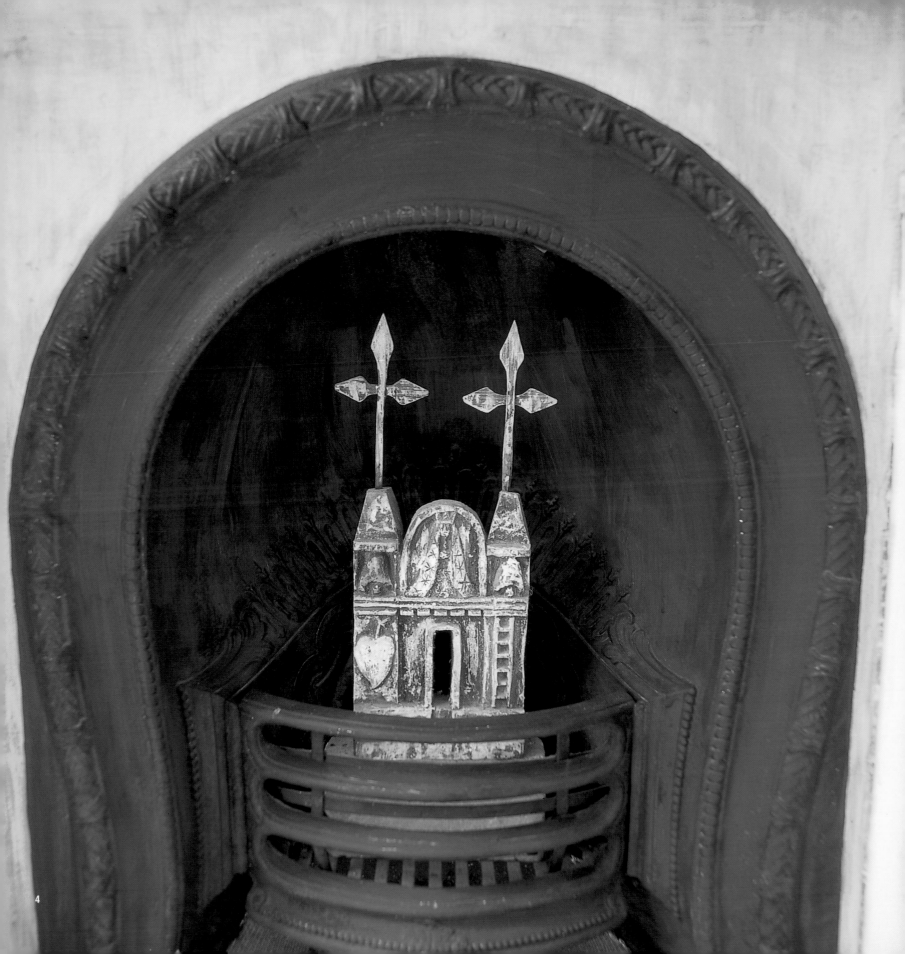

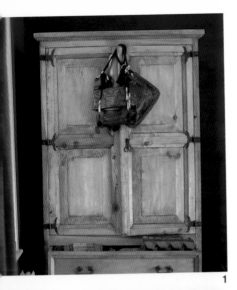

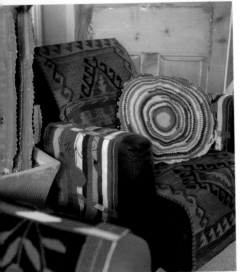

[1] Leather saddlebags hang from the door of a solid timber wardrobe from India. The more homemade and imperfect a piece of furniture looks the better.

[2] Trinkets from abroad can be used to customize plain retail purchases. The votive symbols, or charms, are familiar Mexican images.

[3] The handmade quality of these textiles is evident by their simple geometric designs. Choose woven rather than printed fabrics to lend real rustic charm to your furniture.

that Tikki-Polynesian style. Never be afraid to break the house rules. There is no reason why you cannot tile a wall or two from floor to ceiling in your living room. Western culture traditionally uses tiles only in bathrooms and kitchens, but by checkerboarding tiles in bold North African colors and scattering rugs and bean bags on the floor you can turn your sitting room into the most exotic room of your house or apartment.

Just like colors, different patterns and ornamental designs can be associated with specific countries, or even regions of countries. Ornamental design finds its way into architecture, textiles, furniture and domestic crafts. Choosing the right surface design in the appropriate color range can provide a shorthand mark for your global interior. For eastern European countries, it is stylized folk art with very simple two-dimensional motifs. In Morocco, all designs are built upon geometric principles, so your designs should feature squares, diamonds, triangles and hexagons. Choose materials that feature the right sort of designs for the style you are trying to re-create.

To furnish your global interior, again look at what is characteristic. It is not practical to bring large pieces of furniture back from your voyage abroad, but this does not really matter. Many pieces are already exported from countries around the world, and sold through specialty shops. Endeavor to find handmade-looking pieces that have irregularities and show signs of not being factory produced. You want pieces that express their ethnic origins.

It is also quite easy to create the "look" without necessarily having the real thing. Try buying simple, basic pieces of furniture such as unfinished pine tables, cupboards, drawers and beds, and customizing them. You can find this basic type of furniture in most downtown and suburban industrial shops. Turn items into decorative features with whatever is appropriate—paints, stains, waxes or stenciled patterns. To give it a well-traveled, made-in-a-small-village, ethnic makeover, try distressing the furniture after you have painted it by giving it dents and bruises with a hammer, and aging it with a mixture of stains and waxes. Complete the look by changing the fixtures such as hinges and handles for more crude, blacksmith-made, metal examples.

Textiles will play a vital role in the transformation of your interior. Their versatility means they can be used to disguise some of your existing furniture. Choose the right textile colors and designs for rugs, throws, cushions and small panels of fabric, and layer them on sofas, armchairs, beds and floors for sumptuous styling.

For extra embellishments, explore local markets. With our modern, culturally integrated societies, it is now possible to find an infinite selection of foreign goods without having to travel abroad. Also check out specialty shops that stock international crafts and works of art. Most countries are usually represented. Then of course there are the fruits of your expeditions abroad: a lantern, a kilim, a novelty knickknack, and even authentic tiles for your bathroom.

To enhance further the flavor of your fantasy home, consider the addition of some organic details. Arrange plants and flowers that are normally associated with foreign habitats in strategic and prominent positions. You will be surprised how

much these details will contribute to the tone of your home. Cacti are evocative of the wild west, deserts and scorching climates, ferns and palms of tropical jungles. Exotic flowers like birds of paradise are associated with the tropics. Also consider arranging a bowl of foreign fruits or vegetables as a centerpiece for your table. A rustic bowl with ears of sweet corn, complete with husks, provides a great clue in a Mexican theme.

Plant and produce containers also become a detail to consider. When shopping for items, look out for pots covered in jewel-like mosaics and jazzily designed enamels. These are definitely items you can pick up abroad.

If you want to go the whole way in transforming your urban apartment into a far-off isle, then give two of your other senses besides your sight an exotic treat as well. Add the relevant ethnic sounds to your music collection, and maybe burn incense to give your interior a global aroma. Color, ornamental design, furniture, plants, sounds and smells will all contribute to the mood or ambience of the country of your dreams. The final detail that clinches the effect is lighting, both natural and artificial. To give your interior the right mood during the day, unless it has a northern European style, limit or modify the amount of light coming through your windows. People in most hot countries use shutters to keep the heat of the midday sun out of their homes. Add hinged, louvered shutters to the inside of your windows. You may not need them for the sun but they will give a pleasant broken-light effect to the room, similar to that produced by Venetian blinds. Painted louvered shutters look equally effective when left open, just hinged back against the walls of the room. Alternatively, drape lightweight sheer fabrics over the windows. White will give a soft, romantic mood while bold colors will saturate the room with a soft, exotic ambience.

For artificial lighting, research or observations from your travels will tell you what sort of light fixtures you need, but as a general rule those for hot countries should have a handmade look—choose those made from handbeaten and dull metals, not ones that are slick and looking as if they have come from a department store.

Moroccan and Middle Eastern light fixtures are very recognizable; they are usually in the form of metal lanterns, either suspended or designed for tables, made into intricate shapes. They have clear and colored panels of glass or pierced geometric patterns or holes, or both. These are particularly effective at generating instant ambience by projecting broken patterns of light onto immediately surrounding surfaces. The Mexican style is similar in that it uses pierced sheet metal for lamps and lanterns, but they are usually in a galvanized-tin finish, and the patterns are more figurative, often based on images from the "Day of the Dead" festival.

These and other items are available from stores and markets that import from foreign countries, but many downtown and furniture chain stores have caught onto the fashion for global interior styles and produce pieces that have similar styling or are made of similar materials. Here you will have to use your own judgment in deciding how convincing they are. It will eventually depend on how well you choose items, and how you put them together, as to whether your global look is successful or not.

4

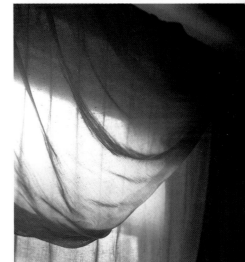

[4] A collection of strange seedpods and pebbles have been arranged to make an attractive souvenir display on a hall table. Found items from your travels will help authenticate the desired style.

[5] When casually draped across windows, sheer fabrics will soften the incoming daylight and give a romantic bedouin-tent overtone to the room.

[6] A pierced Moroccan lantern illuminates a Mexican papier-mâché devil with an atmospheric "speckled" light.

5

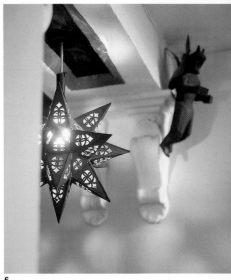

6

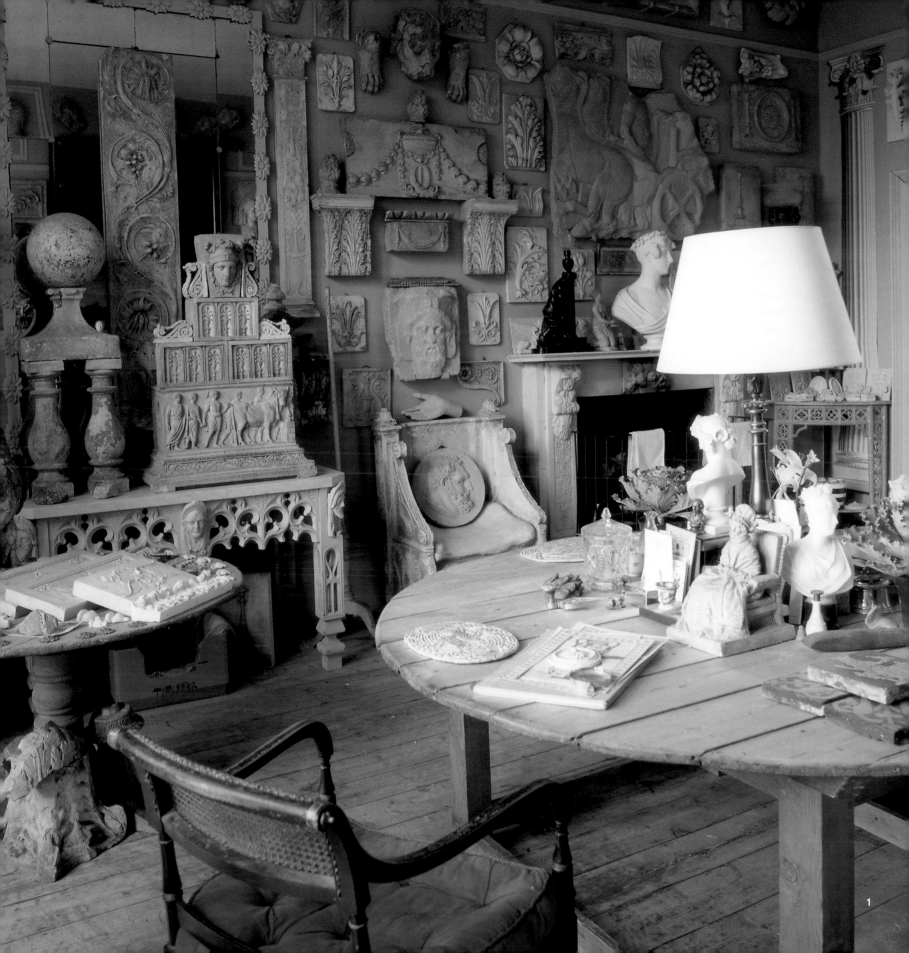

6 CLASSICAL

IN THE EIGHTEENTH CENTURY, FASCINA-
TION WITH THE ANCIENT CIVILIZATIONS
OF ROME, GREECE AND EGYPT INFLU-
ENCED ARCHITECTS AND DESIGNERS.
THE CLASSICAL STYLE RE-CREATES THIS
GEORGIAN FEEL THROUGH A COMBINA-
TION OF FURNISHINGS AND ORNAMENTS.

[1] An incredible collection of carved-
stone and plasterwork artifacts sets the
tone for this classical interior. By incorpo-
rating predominantly Georgian furniture,
a tranquil and evocative period sanctuary
has been created.

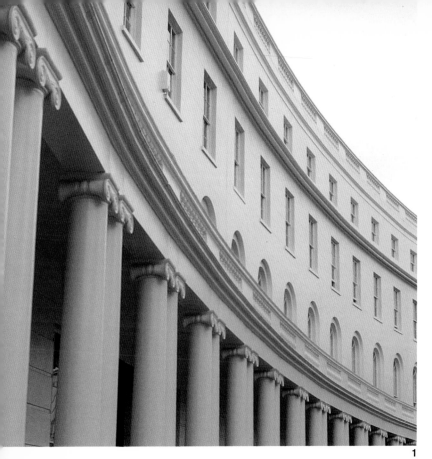

1

[1] Look for classical inspiration while doing the "grand tour" of your own town or city. Columns with Ionic order capitals typify late eighteenth- and early nineteenth-century architecture from the "Greek Revival" years.

[2] A large mirror reflects light coming from the wall immediately opposite back into the room. Its distressed and worse-for-wear condition enhances the "ancient" qualities of everything around it.

The historical roots of any city or town lie hidden among all the traffic jams, fast-food restaurants and high-rise office buildings. These pieces of architecture have survived intact down through time since they were built. Here lies another wonderful source of inspiration.

Absorb this inspiration and give your home a period-style interior, of which there is none more elegant than the classical. This one-bedroom apartment has been transformed into a gentleman's eighteenth-century villa.

The fantastic collection of classical stone and plaster artifacts make up the architectural bones of the interior. Amassed over many years of collecting, these fragments of architectural ornament have been turned into a stunning display that sets the tone for the entire apartment.

Before you consider a similar transformation for your home, it is important to understand how the classical style evolved and why some form of a collection should be an integral part of your furnishings. By the mid-1700s, the ruins of the great ancient civilizations such as Rome, Greece and Egypt had been rediscovered, which set alight a curiosity and a passion for Georgian scholars. Those who were wealthy enough to travel went abroad to gaze upon "the sights" and bring back ancient antiquities as souvenirs. Possessing a collection of art or antiquities was only for the privileged. Collecting was both fashionable and highly competitive. Rivalry between friends meant that they went to great lengths to display their pieces, and in the process set a standard for their interiors.

Some of those who visited the ancient ruins were architects who studied and recorded what they saw, publishing their discoveries when they returned home. These books had a profound influence on the designs of new architecture and furniture that was built from then on. This revised-classical style of the late-Georgian period is known as Neoclassicism.

It is this combination of "collection" and "ancient civilization" that will furnish your interior with its final classical stamp, but first you must consider the palette of your walls. Neutral colors such as gray, beige, sand and pale dusty pinks are great background colors. Try not to use white, since the contrast between it and objects placed against it can be quite stark. A pale cream would work better. Here a pale warm gray has been used, which allows the subtle variety of textures and tints in the architectural collection to register. The wonderful mood created by this almost monochromatic color scheme is extremely relaxing and tranquil, and quite suitable as an escape from the hustle and bustle of modern life. This is what you are aiming for—think quiet, classical, ancient ruins.

To maintain the period feel, the floors are uncovered, exposing the original timber boards, with the occasional rug thrown on top. Wall-to-wall carpets will not suit an authentic period-style apartment; in fact, they will tend to detract from it. Floorboards can be "limed" to give them a paler look, and rugs should have an "eastern" quality to them. Look out for old, faded and worn rugs at local auction houses that will give you

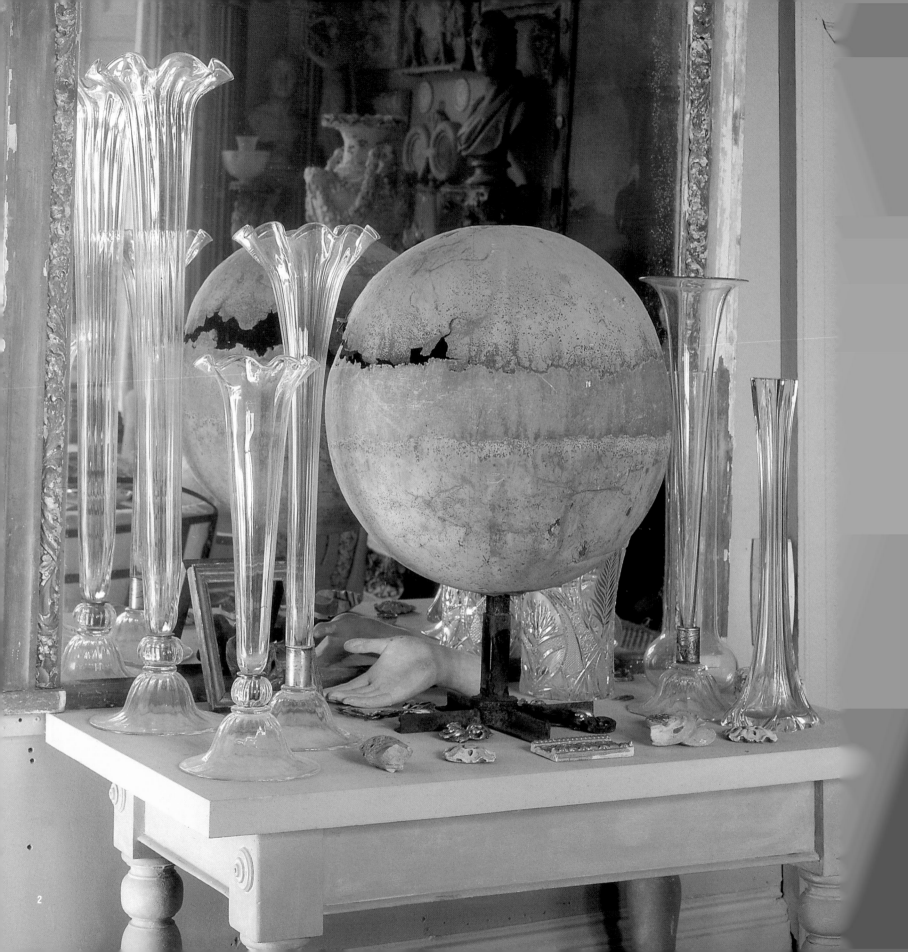

style without breaking the bank. Also consider modern kilims, which can be bought in retail stores and markets, as relatively inexpensive alternatives.

For the classical Georgian living room, avoid too many fussy surfaces such as drapes and swags. The more elaborate it becomes the more it will start looking like a Victorian parlor. Instead, allow the elegance of architectural details such as baseboards, door architraving and paneled window shutters to stand out. If you live in a modern apartment that lacks these details, do not be afraid to put them in. This is not as expensive, or difficult to do, as you might think, especially if you take a resourceful approach. Moldings, for door and window frames, and baseboards are available from most lumberyards.

Original paneled doors and shutters can be found in architectural salvage yards, and decorative plaster ceiling cornices can be bought by the foot from do-it-yourself stores. Ceiling cornicing is also made in plastic, which is cheaper, and looks equally effective once it has been painted. Then, of course, there are dumpsters. Have a look in dumpsters situated near old properties that are being renovated. Period door shutters and other details are still frequently thrown away by unsympathetic building contractors. It is far better that you rescue and use them yourself than for them to be dumped. It is ironic to think that the Georgians plundered the ruins of ancient civilizations to decorate their homes while now we plunder what remains of a Georgian property when it too has become a ruin.

Furniture should be simple and unpretentious. The main furniture makers of the late eighteenth century took their inspiration from early Greek and Roman designs, so avoid the fussier baroque style of early Georgian furniture. You will not have to buy valuable antiques to furnish your classical home. Reproduction furniture will give you the desired effect, providing you choose pieces that are typical for the period. Chinese style or "chinoiserie" and the Gothic style was also becoming fashionable by the end of the 1700s, so the odd piece in either of these styles will not be totally out of place.

Choose furniture in either oak or pine for a lighter look. Darker mahogany examples will tend to make the room appear heavier. Modern inexpensive pieces can be made to work after they have been treated with either paints or stains to age and distress them. A wash of watered-down white emulsion, for instance, can give a modern pine table a bleached, limed effect. Visit auction houses and junk shops to find secondhand reproduction furniture. Do not worry if they are a bit tattered, as this will enhance their "antique" quality. Chairs can always be reupholstered, or slipcovers made to go over them. Use modern copies of eighteenth-century fabrics in this case, such as brocades, damasks, Toile-de-Jouy cottons, Regency-stripe silks, or even plain white calicos. For the final touch, look out in junk shops and flea markets for secondhand napkins that have embroidered monograms in their corners. These initials can be cut out and appliquéd onto plain linens and calicos to be made up into stately looking cushions.

For the definitive detailing of your interior, take inspiration from the ancient Greek and Roman civilizations just as our Georgian ancestors did 250 years ago.

2

[1] Choosing the correct style of furniture for the period is essential. This high-backed, winged easy chair is typical of the eighteenth century.

[2] A modern bamboo armchair with latticework in the Chinese manner sits at home among its eighteenth-century surroundings. Elaborate draperies frame the urban view with opulent extravagance.

[3] Books on classical architecture can be a great source of inspiration and reference. Engravings like these were produced during the 1700s by architects who traveled abroad recording the details of ancient antiquities.

[4] The juxtaposition of a tall, elegant glass vase and the globe base of an antique weather vane accentuates the corrosion and oxidization of the globe's copper surface. This beautiful patina is the result of many years of weather exposure.

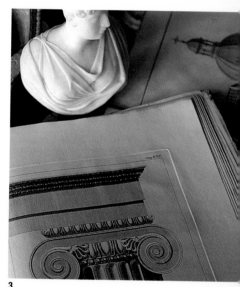

3

4

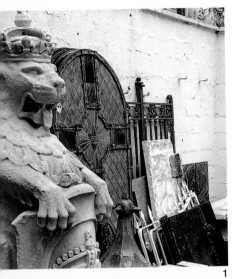

[1] A rather stately stone lion stands guard in an architectural salvage yard. These places are a good source for finding fragments of decorative ornament that have been rescued from demolished or refurbished buildings.

[2] An intriguing display of stone statues and plaster friezes laid out on an oak table evokes the "picturesque"—the name given to architectural ruins of the ancient civilizations during the 1700s.

[3] One inhabitant surveys the world outside his period home. The original window shutters seen behind him are still used in this room as an alternative to curtains.

Read books about these periods and grasp knowledge that will enable you to know what to look out for. Some of the key elements to incorporate in one form or another should be classical columns, bas-relief friezes, urns, ewers, classical motifs, marble busts and statues. These do not have to be museum pieces—look for late-Victorian or early-Edwardian copies. It is the *effect* you want, not the value. Museum shops even make replicas.

Excursions to junk shops could reward you with an alabaster urn that you could turn into a fitting table lamp; or you could give your television a classical touch by standing it on a marble plinth. Wanting an eighteenth-century interior does not mean you have to give up twenty-first-century technology.

This undisputably classical interior is predominantly created by the fine collection of artifacts that lines the walls of the apartment. If you want to create a similar collection, your sources can range from lucky finds pulled out of waste dumps to the odd purchase from a salvage yard or auction house. Remember that a collection can be made up from many small pieces, which individually may be inexpensive. Part of the enjoyment of starting a collection is the actual seeking out and discovery of additions; then it is fun watching it grow.

It does not have to be a collection of decorative stonework—it could be anything that will provide a touch of antiquated eccentricity in an interior. It could be prints, china, marble statues or plaster medallions. The main points to observe are that it should be arranged and displayed formally, and that it is thematic and consistent.

To maintain the atmosphere of the eighteenth century, keep artificial light low-key and ambient. Think museum lighting, with pools of light around the room highlighting the sculptural qualities of classical features. In the eighteenth century, people only had candlelight. Today you can buy electric table lamps with bases that resemble brass or silver candlesticks. For practical reasons, these are probably as close to the eighteenth century as you should get, other than reverting to candles.

Use large mirrors to reflect daylight around the room and add an "extra dimension" to your collection. Look for gilt frames or frames with their original faded paintwork on them. Badly damaged mirrors can usually be picked up cheaply, and are far more desirable, especially if the glass "silvering" is showing its age. Their deterioration will enhance the antiquity theme.

Obviously you can give your interior a period makeover of your choice. Through extensive research in libraries and museums, and viewing original period properties, you can learn what essential details you need to be looking for. It does not have to look old-fashioned, either.

Interestingly, despite the overwhelming collection, in this apartment the final effect is neither cluttered nor stuffy. Its cohesive styling and limited color palette actually manage to give the impression of it being spartan and rustic. With the move by other city dwellers towards simpler, more rustic living in loft apartments, this seems surprisingly fresh and modern by comparison.

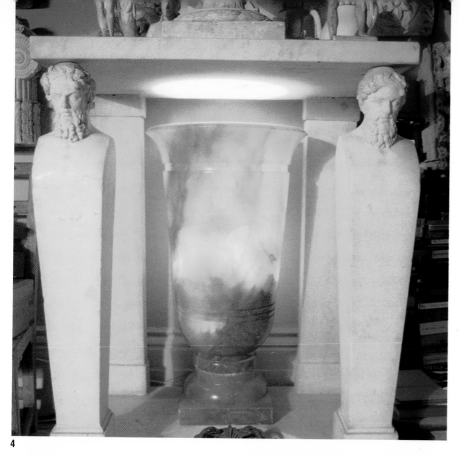

4

5

6

[4&5] An alabaster uplighter is given the classical treatment by "dressing" it with statues and architectural fragments. This gives the illusion of a fireplace within the room. The variegated warm coloring of this lamp bestows a moody and atmospheric ambience upon the interior at night.

[6] Original timber flooring and mirrored wall panels demonstrate the beauty of age. The silvering behind the mirror glass is starting to speckle, adding a degree of authenticity to the period setting.

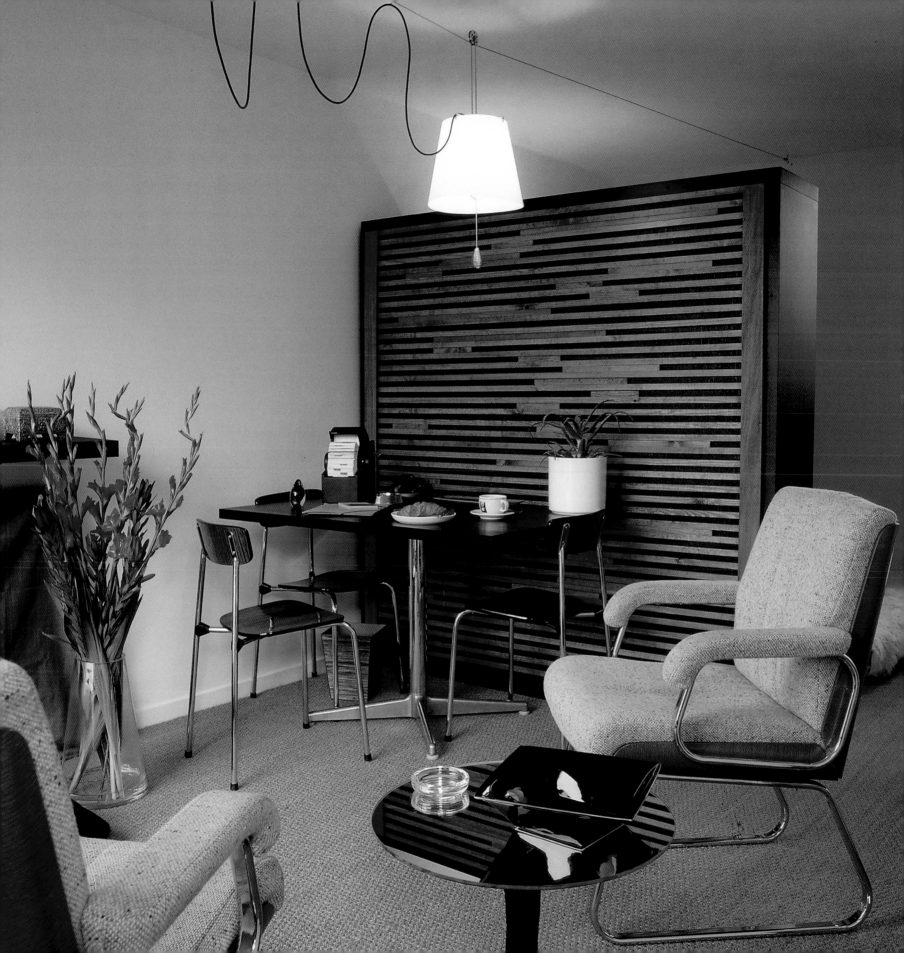

7 SOFT MODERNISM

SOFT MODERNISM IS CHARACTERIZED BY MODERN, DYNAMIC-SHAPED FURNITURE, THE USE OF NATURAL MATERIALS AND THE INCLUSION OF PLAYFUL DECORATIVE ITEMS. IT IS A SOFTER, MORE FRIENDLY APPROACH THAN THE AUSTERE STYLE OF THE PREWAR YEARS.

2

[1] A mixture of retro office furniture, soft lighting and natural-fiber flooring creates a relaxed easy-living style of interior. An open-plan arrangement like this would have been considered very avant-garde in the 1950s.

[2] This style of window frame, with a single, large, pivot-hinged opening, is a clue to the apartment's 1970s architecture. The frosted panel in the lower half of the window provides privacy from the outside world.

Of all the homes featured in this chapter, this is undoubtedly the most resourceful and innovatively decorated. Based on a shoestring budget and with limited space, this apartment has been turned into a stylish showcase illustrating sound interior design skills.

The overall look is primarily an example of retro-styling, where a design style from the twentieth century has been adopted and reinterpreted with a fresh approach. In this case it is based on the Contemporary or soft Modernist style that evolved during the years after World War II and continued through into the 1970s.

[1] A collection of Contemporary-style glass exemplifies the design ethos for postwar furnishings—simple but dramatic shapes, inspired by nature and the elements.

[2] Customize basic downtown-bought furniture in the style of your choice. The back of this book unit has been covered in textured wallpaper, painted, and then had a random lateral arrangement of wood strips stuck onto it. The wood strips have been stained to finish the look—suggestive of teak decking in a Scandinavian interior from the 1950s.

[3] The section of the space designated as the dining area also doubles up as the workspace, so after breakfast the same table becomes the office desk. The slatted wall-screen provides some texture to the otherwise minimal styling.

[4] Besides its sculptural qualities, the serpentine plastic body of this 1960s table lamp also suggests an element of the swirly psychedelia that was to become so influential in design towards the end of the decade.

1

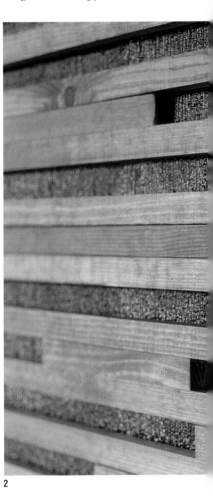

2

This particular period style is well suited to this studio apartment, which is part of an adventurous public housing complex built around the early 1970s. Large, expansive windows are typical for this period of urban architecture, representing a deliberate move by architects to improve the quality of postwar city life. By maximizing the amount of light, a small apartment was made to feel more airy and spacious. A casual, yet chic, interior decor complements this way of thinking.

Postwar interiors of the 1950s leaped forward with an exuberant use of color in a surge of optimism towards a bright new future. Within that reactionary wave came the popular use of the noncolor white. White walls were seen as fresh, modern, clean and unfussy. Juxtaposed against

these white walls, interiors flaunted natural materials, heavily influenced by design doctrines from countries such as Sweden, Finland and Denmark. Their philosophy was to make the integral qualities of natural materials predominant even when used in mass-produced furniture.

Homes all over Europe adopted this look as the modern style of living: white walls, exposed stone fireplace and hearth, open-plan living room/dining room, teak parquet flooring and open-structured staircases of birch or beech.

The four main structural walls in this example have been painted white but have

 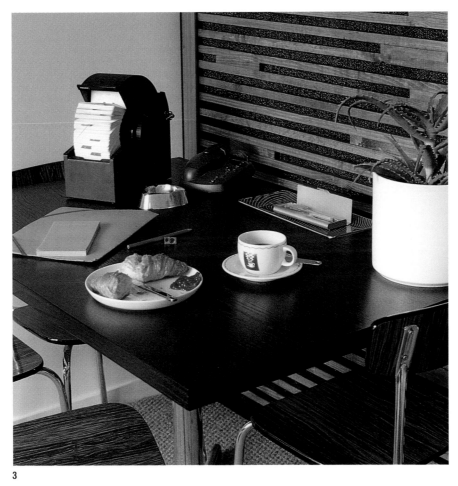

3　　　　　　　　　　　　　　　　　　　　　　　　　　4

been "broken up" by a "temporary" wall that dissects the room. The teak-stained timber strips on this screen between the sitting and sleeping area introduce a touch of Scandinavian styling, thereby adding texture and warm tones to the interior. This "panel" of texture, which is actually the customized reverse of a bookcase, alternatively could have been applied directly to a structural wall as a way to designate a specific area within a room—a place to eat or work in, for instance. This is a neat and economical way to define and allocate space, particularly when the interior is designed with an open-plan arrangement. Other ways to allocate areas via wall decoration might be with a large, framed painting or print, or for that funky eclectic touch a retro rug mounted on the wall.

[1] The reverse side of this wood-slatted panel reveals a storage system for books and magazines. This customized bookcase forms a movable wall between dining/living room and bedroom.

[2] The use of natural coir matting on the floor makes the tone of the space softer and more homey, despite the hard surfaces of modern materials in the apartment, such as steel, laminates and plexiglass.

[3] Office chairs like these epitomize the look of postwar furniture, which took advantage of the latest materials and technology. A faux-wood laminated seat, complete with molded organic curves and mounted onto chromed tubular-steel legs, maintains its light weight and ability to be stacked to create space.

The floors have been carpeted with wall-to-wall coir matting (coconut fibers), which is more informal than traditional carpet, and adds warmth and texture to the space. It also gives a nice "earthy" slant to the room, which balances out the pure white walls and corporate-looking furniture. A rich-toned wooden floor would achieve the same effect, and, although other materials such as marble or polished slate would also work, they would ideally need to be offset with rush, sisal or coir mats to soften them. For a really decadent lounge-lizard look, you could always try a sheepskin rug on the floor.

The majority of furniture and furnishings produced after World War II were referred to as being in the "Contemporary style," a term used to distinguish the latest designs that expressed the new organic outlines and lyrical shapes. This styling was led by a vanguard of English, Scandinavian, Italian and American designers, who took advantage of the newest materials and the latest technology to create fresh and exciting home and office furnishings.

Like all stylish, well-made examples of design, furniture is often more fully appreciated after it has had time to mature over a couple of decades. People look back and compare them with the modern equivalents and suddenly start to appreciate the uniqueness of what has gone before. It is then that these retro examples are declared classics and become highly collectable, and unfortunately often overpriced.

If, however, your budget will not stretch to desirable collectables, it is still possible to find furniture that will give you the desired look. Contemporary-style furniture is characterized by surface pattern and expressive shapes. Look for examples that are made from molded plywood or plastic, faux-wood laminates and unusual cast-aluminum or tubular-steel frames. For dining, you might want to consider molded plywood stacking chairs, the sort that used to be seen in school and church halls. These stacking chairs were later replaced by the molded plastic type with metal legs, which had more of the 1960s space-age look to them. Alternatively, consider office chairs from the same period. Investigate secondhand office-furniture stores, junk shops, auction houses and specialty retro-style shops for ideas. The small, occasional tables in this example cost virtually nothing, as they were made from thrown-out department-store display stands. The only cost was getting pieces of mirror glass cut to shape for the tabletops. Always think imaginatively when you spot unwanted materials in dumpsters or in the street, especially if they are materials that were popular during a specific retro period.

During the 1950s and 1960s, the relationship between people and their environment in the office led to a corporate-contemporary style of furnishings. Besides nurturing the efficiency of employees, the office also became a place to seduce and lull clients. Office furniture evolved into a sexy, masculine mix of black leather upholstery, chrome and wood or wood finishes. In the home, seductive white furnishings from television sets to sofas became the ultimate symbols of chic, as the world geared up for the space age and the first man on the moon. As we embark on the twenty-first

century, interior designers and trendy homeowners are looking back at these 1970s styles with nostalgic awe, not only incorporating furniture examples in their homes, but also adopting a 1970s lifestyle with music and clothing.

For retro accessories and details, have a look around modern fashionable stores downtown. Because of the popularity for retro interiors, many modern goods today display characteristics from the past. It is now possible to buy lamps, ceramics, furniture, electrical goods, fabrics and glass that distinctly show they have been influenced by the Contemporary style. This means you can quite easily mix the old with the new and still manage to keep a cohesive look to your interior. More importantly, by shopping around with a keen eye, it is possible to furnish your home on a limited budget.

One of the classic icons of the 1960s that is being reproduced today is the lava lamp. Its space-age rocket shape, and its psychedelic, ever-changing, amorphous blobs of hot wax, has changed its status over the last ten years. From being a kitsch collectable of the 1960s, it has now obtained cult status, and is considered one of the most stylish accessories for the ultra-modern home.

Much of the lighting fixture design of this period was Italian, which was synonymous with a suggestive affluence and sophistication, often associated with bachelor pads and playboys. The mere suggested association of examples such as these can evoke a certain style and attitude in your home. Other 1960s or early-1970s space-age lamp designs, such as chrome arc lights and glass "mushroom" lamps, were way ahead of their time and not fully appreciated as much as they are today. They look quite at home in the new wave of open-plan, loft-style urban interiors.

When choosing your lighting accessories, look for the understated, with simple shapes: for example, opaque-white glass domes and spheres, or other geometric and organic shapes that express the technology of their period, such as molded plastic or plexiglass.

The retro-styling you choose as the basis for your interior is entirely up to you. Whether it's the "boomerang" style of the 1950s, the pop-art shapes of the 1960s, or the sleek Italian look of the 1970s or a mixture of them all, your aim should be to reinterpret the look rather than mimic it completely. Mix it with modern furnishing examples to give it a fresh, clean look for today.

4

5

[4] A simple arrangement of objects on a mirrored tabletop provides a low-key but sophisticated focal point for the room. The table lamp exhibits some of the eclectic aspects of 1970s furnishings—classical styling with a twist of Italian pop art.

[5] In small apartments, you have to be extremely innovative to make the most of the available space. Here a taut steel cable stretches from one side of the room to the other, enabling the ceiling light fixture to be dragged from the dining area, over the top of the wall screen, and into the bedroom area when required.

[6] Daylight is softened and diffused, but not cut out completely, by a pale linen roller blind. The framed subway map hangs on a wall as if to verify that the occupant is an urban dweller.

6

CREATING **SPACES**

[1] According to Feng Shui, clutter and mess creates low energy levels, which is linked with tiredness and frustration. The simplicity and serenity of this dining area would surely not allow your thoughts to become clouded.

[2] The glass-brick wall of the aquarium allows light to pass through into the kitchen area. It is an innovative and dynamic solution to the problem of dividing up space.

WALLS WITHIN WALLS

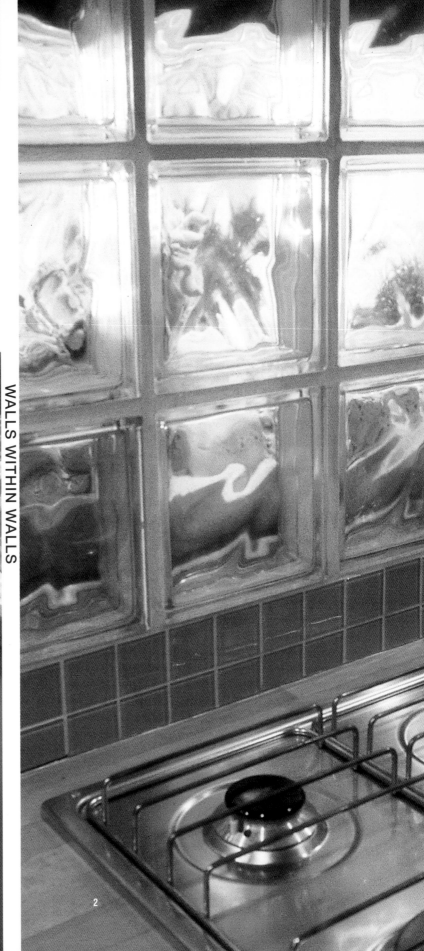

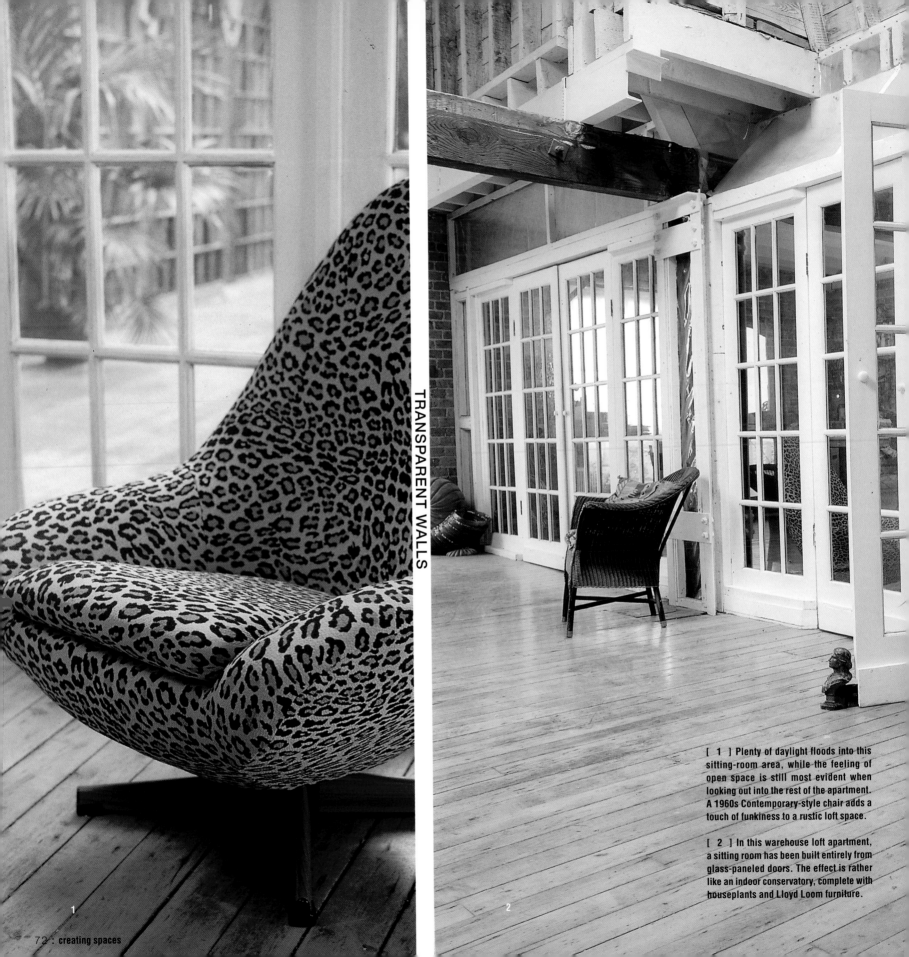

[1] Plenty of daylight floods into this sitting-room area, while the feeling of open space is still most evident when looking out into the rest of the apartment. A 1960s Contemporary-style chair adds a touch of funkiness to a rustic loft space.

[2] In this warehouse loft apartment, a sitting room has been built entirely from glass-paneled doors. The effect is rather like an indoor conservatory, complete with houseplants and Lloyd Loom furniture.

[3&4] A raised floor level is a simple but effective way to define zones in a living space. The white screens seen in the distance can be drawn across to define another space, that is used for relaxing and watching TV.

FLOORS AS WALLS

WALLS WITHIN **WALLS**

Maximizing the use of available space has become a key issue in the planning of urban dwellings. As the price of urban residences continues to soar, the amount of space you get for your money continues to plummet. The combination of an ever-increasing influx of people into towns and cities and the change of social attitudes towards staying single longer, and consequently wanting to live alone, has put a serious strain on the housing market.

One solution has been for property developers to squeeze more apartments into single buildings, thereby creating smaller, compact apartments. Even traditional townhouses, originally built for one family to live in, are now frequently divided up so that each room becomes the entire home for somebody. This type of space is called a studio apartment. To enable people to live in or own a home in the city, this small amount of space has become quite normal; but it means that much more thought has to be put into interior design in order to utilize the limited space effectively. In a single studio apartment, provision of areas for eating, relaxing, cooking, washing and sleeping must be considered, but without the end result appearing to be claustrophobic, uncomfortable or impractical.

Small spaces usually demand an open-plan arrangement so that the "internal horizon" is expanded as far as possible. Avoid adding walls and boxing off space and light. A low wall, for example, between a kitchen and dining area, is fine, as it merely distinguishes between the two areas without losing sight of the outer peripheral boundary walls. If you want dividers between, say, your living and sleeping areas, there are several options other than solid walls. Screens are a good solution because they are movable, and they allow a certain amount of light to travel over the top of them into the space beyond. Another solution is to hang light fabric drapes. Choose light-colored muslins to create a tent effect around your bed; these can be draped or drawn back during the day as an elegant feature of the room.

The only room that needs any form of solid wall is the bathroom or shower, but even here try to avoid a structure that does not allow some percentage of light to pass through it. Frosted plate glass or frosted glass bricks should provide enough privacy without making you feel your studio space has shrunk dramatically. For the rest of your apartment, if wall divisions already exist and you do not want to demolish them, try just removing the doors. This will allow one area of your space to "bleed" out into the next, giving the illusion of openness.

Follow some of the other main design rules for small spaces, such as avoiding clutter. This goes hand in hand with plenty of clever storage, of which you can never have enough in any home, large or small. It is essential for hiding away the bits and pieces that make a space look busy and confusing, whether they are clothes, cooking utensils, books or magazines. Locating places that can become discreet storage areas will require extreme innovation and resourcefulness on your part. Storage is

1

2

[1] The illusion of a larger space is created in this studio apartment with the white-painted walls, plain flooring and simple but stylish furniture. The ingenious use of the screen-cum-bookcase creates an attractive and practical barrier between living area and bedroom space.

[2] The other side of the customized bookcase reveals its storage facility and the bedroom area. Not only is this more useful than a traditional wall, but it also allows daylight to enter over the top, and most importantly, it is easily moved.

part of the overall streamlining approach you will need to apply to every square inch of your small space.

Keep furnishings down to the bare essentials and coordinate them as much as possible so that your eye is not constantly distracted. Keep colors light, and avoid dark woods where possible. Paint walls and ceilings white or a very pale color so that light is bounced around the room to make it bright and airy. Good but unobtrusive artificial lighting, such as recessed halogen spotlights, will maintain this bright and airy feel even at night.

Do not hang heavy curtains around your windows because they have a tendency to overpower a small space. Instead, use shutters and blinds, or very sheer fabrics that still look light and airy even when drawn. Alternatively, have nothing at all at the windows and replace lower panes or sections of window frames with frosted glass. This maintains privacy but still allows the maximum amount of light to enter the room.

Ultimately, it is important to remember that it is not just the size of your space that is important, but the quality of your space. Using space imaginatively can improve the quality of life, which many people are finding is true by following the principles of Feng Shui.

Feng Shui is a philosophy based on ancient eastern concepts that show how your physical surroundings can affect every aspect of your life. It identifies the positive, negative and neutral areas of energy in a room and tells you what influences they can have on the activities normally carried out there. By arranging furniture, light, plants and even aquariums, the positive energy of your home or place of work can be increased, thereby improving your lifestyle and well-being. The rigors of urban living mean that more and more people are turning to this ancient art form to lay out their homes, especially where space is limited, in the belief that it will bring them health, wealth and happiness.

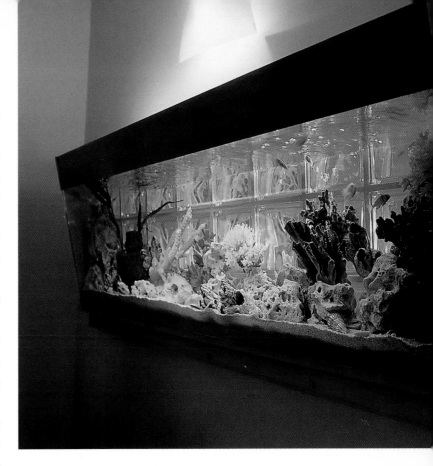

Fish tanks and other water features in your home will attract good fortune according to Feng Shui. In addition to this, aquariums are trendy and the latest fashion accessory for interiors. This one acts as a boundary device between the dining area and the kitchen.

TRANSPARENT WALLS

It may sound surprising, but if you are lucky enough to live in a large space, particularly an industrial loft conversion that has been sold in its raw, shell-like state, then you can end up having exactly the same dilemmas as presented by a tiny studio space. Faced with the luxury of a vast, open space in the heart of the cramped urban environment, there is the overwhelming urge to keep it as close to empty as possible. We do have to break up this space in the end, however subtly, in order to allocate areas to some of the unavoidable routines of living, such as eating, cooking, sleeping and washing.

Deciding how to go about this dissection of space, without losing any of the valuable daylight that makes it so inspiring and attractive in the first place, is a considerable challenge. Like most urban apartments, loft spaces usually have windows located at one end of the space or around its periphery. Any inclusion of solid walls

[1] Glass bricks provide a distorted privacy from the next room, but do not hinder the amount of daylight that permeates them.

[2] A central construction of walls within a larger, open-plan industrial loft space forms the self-contained kitchen area. The solid walls provide the necessary space for built-in cabinets, drawers, and larger units such as the stove and refrigerator. By creating an "island" within the space, light is allowed to circulate around the surfaces.

[3] Eliminate doors or dense barriers that will block the passage of daylight through space. A room at the end of this "galley" kitchen has a glass-brick wall to allow daylight to pass through it from the window beyond. Daylight can penetrate this kitchen area from three different directions, accentuating its clean and fresh appearance.

[4] The dynamic black-and-white stripes painted on the floorboards of this studio apartment delineate the outer periphery of the living area. The painted checkerboard pattern defines the center of this space.

[5] A mezzanine level has been created in a high-ceilinged warehouse apartment for a bedroom. Instead of solid walls, long lengths of sheer white muslin have been hung from the rafters to create the room space.

between that light source and the rest of the apartment automatically means having unwanted shadows and darkness. The choices are to have no boundary walls at all, to have low or fragmented walls, or to have complete walls that can provide privacy and sound exclusion but still allow daylight to pass through them. Glass is the ideal solution to keep light loss to a minimum, and can be used in a variety of ways.

Clear sheets of glass, however, are not recommended. Frosted glass is a better option as it not only reduces the risk of accident, but also avoids the goldfish-bowl appearance of sheet glass. Glass-paneled windows and doors can be used to designate rooms or areas, and are available in a choice of clear, frosted or stained glass.

Using windows to create rooms within a large space keeps the smaller subdivided areas bright and airy, as well as donating an outside flavor to the inside. Look for unusual windows, such as those with industrial cast-iron or steel frames, at architectural salvage yards. Metal frames do not rot like those made from timber, so they retain their structural strength. Usually they just need sandblasting and painting. Only glaze them once they are in place, otherwise the multi-glass panes will make the frames too heavy to maneuver.

Another popular way of using glass as a material for walls comes in the form of glass bricks. Glass-brick walls have more soundproofing qualities and offer slightly more privacy than normal clear-glass panes because of their double thickness and distorted, "watery" opacity. Glass bricks will automatically furnish your home with a very modern "industrial" style due to their more frequent nondomestic usage. They can make a room look as cool as an igloo, even in the heat of summer.

Other solutions for nonsolid walls include using large, old, wrought-iron gates as screens to cordon off areas. They will not offer much privacy unless you line them with a light, sheer fabric, but they will add an eighteenth-century elegance to an ultramodern interior.

It is necessary to have some solid walls in all homes, as they help to create storage areas. Try to situate permanent or solid walls as far away from windows as possible so that the available daylight from the window area floods into the apartment as far as it can before it gets blocked. Alternatively, build walls that run away from the window as opposed to being parallel with it. Light can then travel along the wall into the areas beyond rather than hitting it flat on and bouncing back out of the apartment.

FLOORS AS WALLS

If boundary walls, solid or glass, are not for you, then consider other forms of boundaries. To find examples you need only take a walk in your urban environment. A colored line on the road clarifies where people can or cannot park their cars, or where they must stop to give another car right-of-way. Other boundaries are defined by a change of texture or level. In the street, for instance, a pedestrian sidewalk defines

where a person must walk to be safe from passing traffic. Step down off the sidewalk onto the pavement and you have entered the dangerous zone of fast cars. This type of symbolic boundary can exist in the home as well.

Floors can serve a purpose other than that of a base for your furniture: they can delineate space, especially in what is essentially a one-room apartment where traditional walls would gobble up valuable floor and light space. Use the floor to define household areas with a change of either color or fabric. Floorboards might designate the living space, while ceramic tiles might do the same for the kitchen area. A painted border on the same floorboards could map out the dining area. With the limitations of small spaces, you have to think more resourcefully. You need to make every square inch work to its best advantage. This can mean working out your floor plan not just two-dimensionally but also three-dimensionally.

If you are lucky enough to possess high ceilings in your small apartment, consider a raised level or mezzanine. This can be used for a bedroom, workspace or storage area. It is not so much an upstairs in your apartment as an extension of your floor space.

This idea of changing the level of the floor to define zones can be put to good use in large loft apartments that benefit from remaining open plan for reasons other than limited space. Here, raised and sunken floor levels not only perhaps hide central heating and other pipes that would normally run inside walls but also define where one area ends and another begins. It only has to be one step high, yet there is still a natural assumption that you have entered another environment, just as you do when you step up onto the sidewalk in a street.

One imaginative, and daring, use of this approach is to have your bathing area on a raised dais in the middle of your large, open-plan loft space—no walls, just the bathing area simply defined by the raised-floor section.

With the new style of urban interiors, either small studio apartments or sprawling loft apartments, there has been a reshaping of the way we now live. Interiors have evolved and become less conforming to match our more informal lifestyles. Solid walls have disappeared, paving the way for more creative boundaries between rooms. Some of them are so subtle that the points where kitchen, bathing area and dining space all begin and end has become totally blurred.

4

5

ROOM SETS

KITCHENS

LIVING AND DINING AREAS

ABOVE ALL OTHERS, LIVING AND DINING AREAS SPEAK VOLUMES ABOUT OUR PERSONALITIES AND PREFERENCES, AND THESE ARE THE AREAS MOST ENCOUNTERED BY ANY VISITORS TO OUR HOMES. IMAGINATION CAN RUN RIOT, AND THE DESIGN POSSIBILITIES ARE SEEMINGLY ENDLESS.

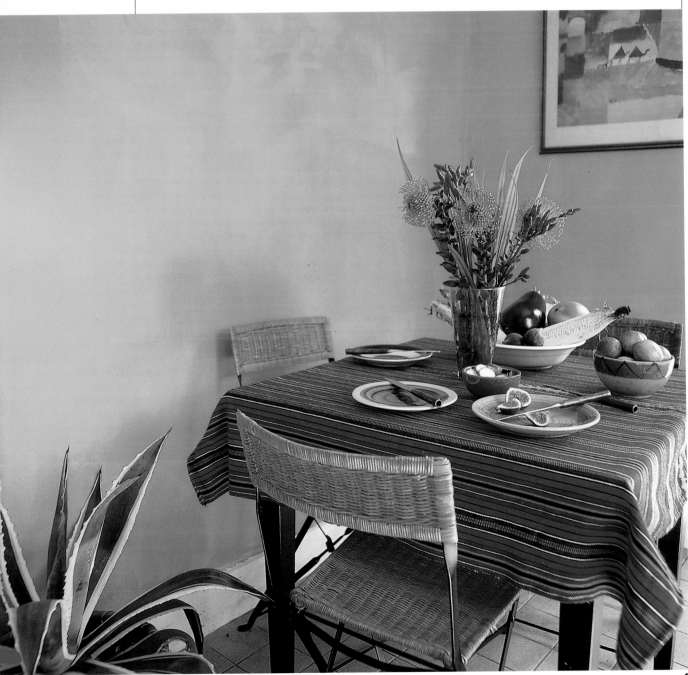

1

3

2

GLOBAL STYLE

Not all urban dwellings have the luxury of a separate room or space reserved for eating. There is usually some form of compromise. Either our relaxation space or our kitchen has to double up as an eating area. A kitchen/dining area can set the atmosphere for a very relaxed and friendly place in which to eat—an intimate place, generally considered the hub of the household, where guests can feel they do not have to stand on ceremony and will immediately feel at ease. This would certainly be true when you entered this Mexican-themed, global-style kitchen. Here, a corner of the kitchen has been set aside as a dining area that would surely convince you that you had traveled to a sunny foreign location just to have lunch. Sitting down to eat should be a pleasure rather than a chore. A simple, uncluttered dining area like this is ideal for a small kitchen, and is extremely easy to achieve. There are only six main ingredients needed to make this imaginative transformation: chairs, tablecloth, exotic plants and flowers, crockery, wall color and floor treatment. It is so easy, but so effective.

The vibrant walls have been "rusticated" with two different tones of tangerine-colored paint, one sponged over the other. It gives the impression of a textured wall, which helps give the room its Mexican flavor. Similar paint-texturing can be used with other colors, and is always a useful device to stop walls from looking flat and lifeless. Floors in kitchens should always be practical to clean. In this "Mexicana" example, plain, stone-colored ceramic tiles have been used. Terra-cotta tiles would also fit with this particular theme, but might make the space seem a little less bright and airy.

Tables for a small dining area like this should not be huge. Keep them neat and small so they do not overpower the space. A table that will seat up to four people is usually big enough, but if you need something bigger and do not really have the permanent space try to find a drop-leaf table that can be extended as and when required. When not in use as a dining table, it can be pushed up against a wall and used as extra workspace in the kitchen. If you own a table that no longer suits your latest interior style, you can disguise it in an instant with a tablecloth. Do not limit yourself to ready-made tablecloths, but buy a length of fabric that really inspires you. Give it a simple machine hem, and you have a unique table cover. Make a series of cloths on a similar theme and alternate them. It is an easy way to brighten any eating space. This jazzy striped cloth donates an "alfresco" flavor to a lunchtime snack.

The final touch that turns this small kitchen corner into a spicy Mexican cantina is the woven wicker seating. Household plastic goods come in some of the most refreshingly bold colors imaginable. Consequently these fold-up chairs are a perfect choice, and of course are completely practical. They are the ideal space-savers. Once "flattened," they can hang on the wall in a cupboard or slide neatly into a crevice somewhere. These particular examples are a good choice for the look that was wanted.

You may be lucky enough to have space for a separate dining area, but eating in the kitchen can have a pleasant informality to it.

[1] Is it a corner of a kitchen or a Mexican cantina? Visualize yourself anywhere in the world next time you have lunch by creating a global-inspired dining area. This example almost resonates with color.

[2] The woven wicker back to a practical fold-up dining chair adds another splash of "spicy orange" to the kitchen's color palette.

[3] Potted cacti around the room suggest hints of the hot Mexican deserts, while the eclectic mix of plant containers provides a touch of whimsy around the dining area.

[4] Choose accessories that complement your global styling. The table crockery for this Mexican setting is glazed earthenware that has been handpainted in bold primary colors with very simple decorative designs.

[5] Make sure you have at least one good light source located directly over the dining table. This galvanized tin shade has a handmade quality to it that complements the rustic choice of decoration.

[6] A small occasional table has been given a mosaic makeover. The four larger decorative tiles were obtained in Mexico and incorporated into the design.

[1] Everything on this table is a bargain find. No matter what they cost, it is the pieces you choose and how you put them together that ultimately gives you the style you are looking for. A candelabra found in a French flea market and a 1940s appliqué tablecloth from a local tag sale give this particular table setting a touch of luxurious decadence.

[2] From baroque to 1960s kitsch—all different styles and periods are represented on this dining table. These plastic "anemone" candleholders lose their pop-art image and instead become "angelic" when interspersed among more classical pieces of table furniture.

[3] Baroque candelabras placed on a dining table are reminiscent of the decaying splendor of the fated Miss Haversham's residence in Dickens' *Great Expectations*. Dress your own dining area with equally evocative elements.

[4] This dining area exemplifies the resourcefulness and innovation of the new breed of urban dwellers. An eclectic mix of furniture and furnishings, bought and found, has been put together for a unique look. The raw state of the warehouse interior enhances the dramatic effect of the banquet table.

[5] Do not be afraid to mix and match dining chairs. There are no rules that say they always have to be a matching set. Buy odd single chairs that you like the look of and build up your own unique set. Examples like this bentwood chair can be picked up quite cheaply in junk shops and at tag sales.

[6] An eccentric touch to the dining area. A shopping basket becomes an attractive plant container when hung on the wall. Always try to have plenty of flowers around your apartment to give it splashes of color and a sense of energy.

[7] A collection of found objects hang in a nonchalant manner from an old coathook. A chain, a wallpaper brush and some painted aluminum letters provide an irreverent still life in this apartment.

WAREHOUSE RUSTIC

If you have the available space, there is nothing quite like entertaining on a grand scale. Setting up a long banquet table for a group of friends might sound like the height of decadence, but I believe it is elevated even more when it is located in such an unusual and unconventional space as this example.

In a spacious, open-plan warehouse loft, a long refectory table is set for dinner. The original bare timber floorboards and the bleached ceiling rafters both help to bestow a simple and rustic ambience. The limits of this casual dining area are loosely defined. It sits behind a wall of Victorian cast-iron factory windows that separate this portion of the apartment from the rest without conventionally boxing it off into a room. The window frames have been deliberately glazed with old and dirty glass, and then never cleaned, to produce an authentic dusty-antique quality. This requires great discipline and a resourceful vision as it is our natural instinct to clean dirty windows, but for this kind of eccentricity perfection is not what you want.

In fact, the whole look for this open-ceiling dining area is based on imperfection and the curious. Its owner has fashioned it along the premise that junk-shop finds and mismatched table-setting pieces will ultimately create a more individual and quirky appearance for the space than if everything was bought brand-new and matching. Touches like the cutlery and crockery not matching, and the chairs all being odd, create a style of its own. The main thing to remember when trying to recreate this look is that although individual pieces are mismatched, they still have something in common with each other that makes it work as a whole.

The plates may be different from each other, but they all have traditional blue-and-white patterns on them. The items of cutlery differ from place-setting to place-setting, but they are nearly all made from silver plate, with or without ivorine handles, and feature a common, distinct, old and used luster. Similarly, none of the dining chairs match, but the mixture of dark-stained oak, beech and bentwood blend together with their rich patina of age.

The end result suggests an improvised affair, thrown together for an impromptu dinner party. Nothing about it looks too formal or precious, which is ultimately what you are aiming for. It is important that a dining area has a relaxed atmosphere because it is more than a place to eat. It is also a place to be sociable and while away the night with good conversation. Dress the table with assorted candelabras and vases or bowls of flowers to keep it friendly and intimate.

If you want to create your own banquet table, but you do not have a table of the right size or the space to have a permanent long table sitting in it, consider using trestle tables. You can then have a table length of your choice simply by adding more trestles, or, if you prefer, L-shaped or large square table settings. They are quick and easy to erect and can be rented just for the evening from companies that supply party furniture, normally for weddings and similar functions.

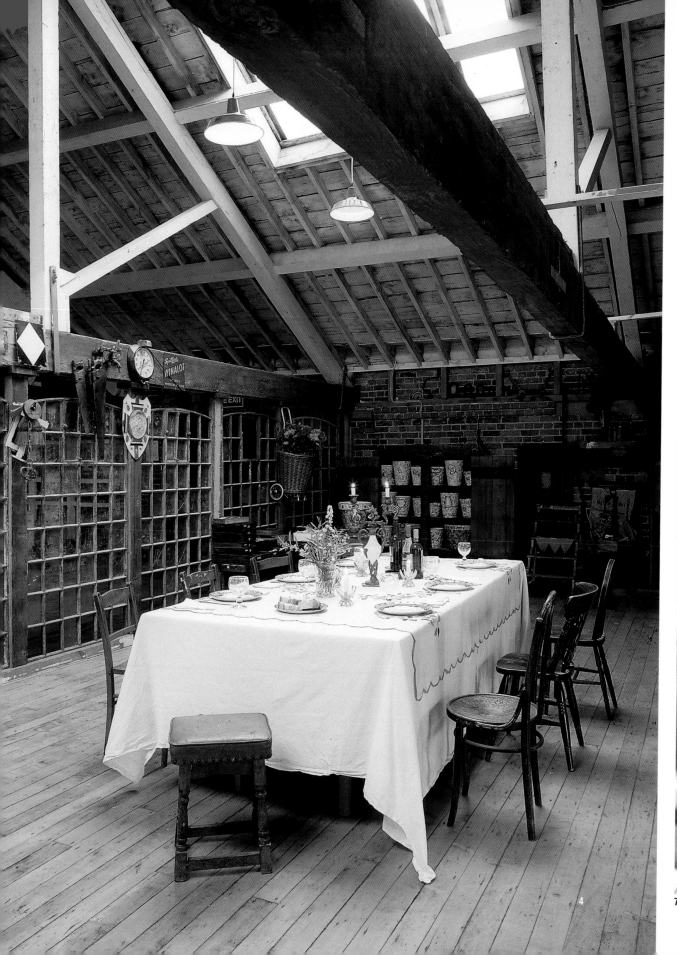

4

5

6

7

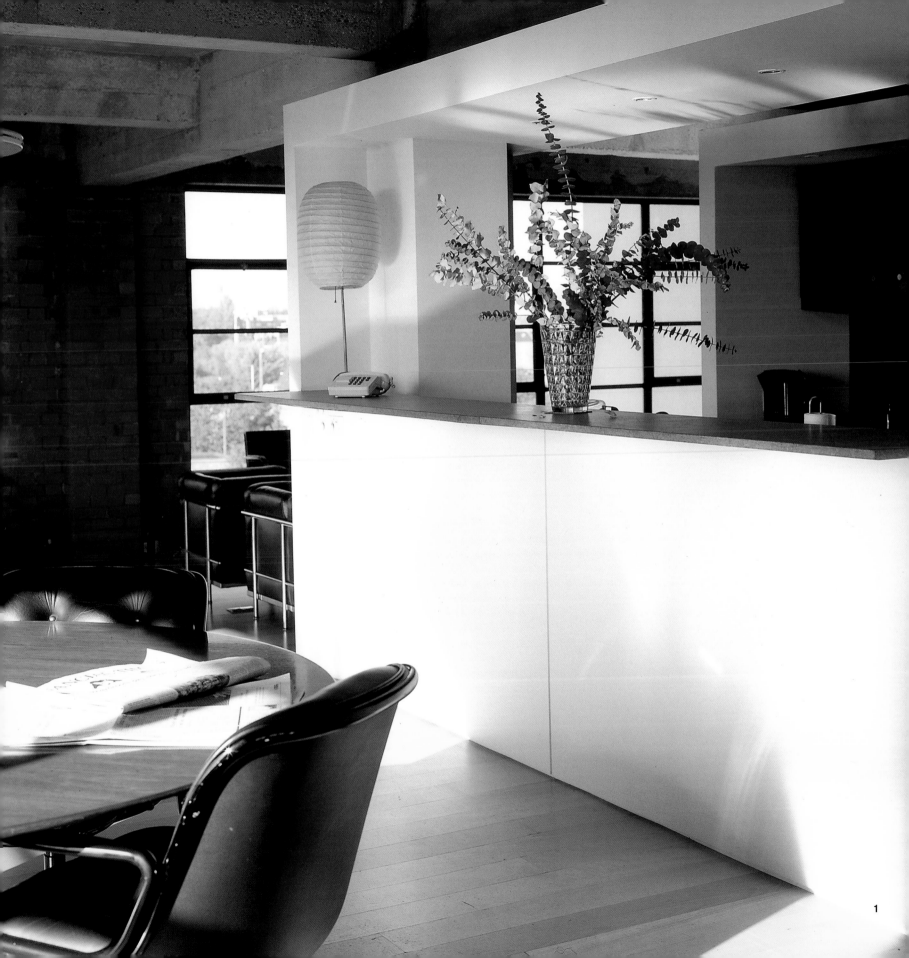

INDUSTRIAL CHIC

Interior design is about more than just matching the right style of sofa to the color tone of the walls. It is about the way you want to feel after spending time in your apartment, and also about how others will react when they come to visit. Space that you spend any amount of time in will undoubtedly have both an initial impact and a longer-lasting effect on your personality. The mood or character of an interior will feed back onto you and affect the way you feel or behave, so it is important to create an environment that reflects your personality, passions and interests.

This open-plan apartment in an old reused industrial property suggests the word "debonair." It is the epitome of an urban apartment in the heart of the city—but that is not to say it is emotionless in its character. Its spacious and almost seamless layout evokes the relaxed, laid-back attitudes of the West Coast, while the choice of furniture retains a business-like efficiency that suggests all is well and under control. Surely when guests enter this apartment they will immediately feel at ease and have no doubts about how well the evening will flow. Here they will be relaxed and dine in style, beginning and ending their courses with the permanent treat of the spectacular panoramic views afforded by the expansive industrial windows.

This apartment has been thoughtfully styled by its owner. The open-plan arrangement maximizes the available space and light while also becoming a valuable asset to his lifestyle. Despite the generous floor space, nothing seems more than an arm's length away. This is because all the designated areas of the apartment are always visible from any given position, thanks to a carefully considered floor plan.

A perfect example of this is the dining area, which has both a close proximity to a more informal relaxation area or sitting room and easy accessibility to the kitchen module. This kitchen, with its room-within-a-room construction, makes a dramatic statement within the space. Its all-white finish seems to capture, reflect and bounce virtually every light ray off its multiple surfaces, giving it a Holy Grail–like aura among the more raw industrial materials of the apartment. While the owner prepares, cooks and serves food to his guests, the cut-out sections mean that he does not miss out on any conversation.

The dining area features a round table, which is the best sort for dinner parties. It is far more intimate and allows everyone to feel involved in dinner conversation. Another novel feature of the dining room area is the office-style chairs, complete with castors. They allow maneuverability, and since we find it so practical to have this style of furniture at work, then why not also at home?

One thing to learn about any interior styling is that forethought and preplanning are essential. Think about all aspects—not just the color scheme. Consider how the interior will "work" for you. Overall, this apartment example is exceptionally well thought out and laid out—functionalism at its best. It is surely a blueprint for the modern urban lifestyle.

[1] Ease of accessibility is what is most apparent in this apartment interior layout. It manages to create a unique balance between informality and drama to achieve a comfortable yet exciting city home.

[2] More and more people now choose to work from home. Not only does it allow for a less stressful lifestyle, but it also means money saved on travel can be reinvested in your home interior.

[3] These office chairs on castors give this dining area a high-powered but funky boardroom look, an impression enhanced by the long stretch of industrial windows offering panoramic views over the city.

[4] The Zen-like qualities of the kitchen area are reinforced by this Japanese paper lantern. It adds peaceful and harmonious lighting to an otherwise dynamic area of the apartment.

2

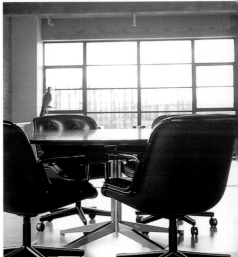

3

4

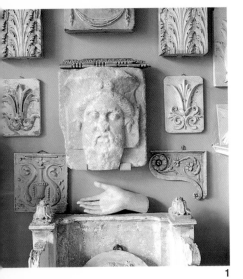

[1] Well-displayed collections like this become works of art to be studied and admired. Your collection should generate intrigue and curiosity in others, but most of all be on view to be enjoyed by yourself.

[2] A beautiful Toile de Jouy cushion gives a rather austere Georgian iron campaign seat a softer look. Modern fabrics with original antique designs like this will add authenticity to your period styling.

[3] Be equally resourceful when choosing flowers and plants for your apartment. A red cabbage adds a splash of royal color to the discreet and antiquated tones of classical accessories.

[4] Step back in time. An eighteenth-century collection provides the elegant background for a combined sitting and dining room. The complementary color tones and the formality of the display prevent the space from appearing cluttered or overpowering.

[5] One of the few obvious concessions to the twenty-first century is the television set in the sitting room, but even that is given a touch of classicism to help it blend in with the rest of the collection.

[6] Who said urban pets cannot have a chic lifestyle too? This one resides in a box beneath a nineteenth-century pierced Gothic-style side table.

CLASSICAL

The modern way of thinking for urban interior decoration is clean, simple, understated and uncluttered. On the whole, this is a good way to think, considering how scarce and extremely valuable urban living space has become. What about those collectomaniacs among us, however, those who are so passionate about an object's historical past or design features that they are not content to restrain themselves to owning just one example. The fact that you live in an urban environment does not mean you have to go minimalist. That is an option that suits others with different lifestyles or different criteria for their homes.

If you have a passion or obsession for collecting, then flaunt it; do not try to hide it away. Home is where the heart is, and if your heart flutters every time you see a 1960s plastic pineapple ice bucket, then so be it. A collection is an expression of yourself, and therefore an important vehicle with which to personalize and turn your empty space into a unique space. Besides, a consistent and well-displayed collection can essentially set the decoration style of your interior, and in so doing may solve many interior-design problems. Questions such as which color your walls should be and which furniture you should add are all answered by making your choice based on what aesthetically works best alongside your collection.

This combined sitting room and dining area is filled with the most magnificent collection of eighteenth-century decorative stone and plasterwork. It lends an elegance to the room that would not exist if it were not for the owner's desire to seek out and safeguard these architectural objets d'art. The majority of the pieces reveal the craftsmanship of a bygone age, an age when every gateway, entrance, window and ceiling would have been graced with intricate, ornate detail. This discerning collection gilds the rest of the apartment with these inherent qualities.

This apartment, along with other examples we have looked at so far, exemplifies the chameleon-like qualities that four walls and a doorway possess. They are merely what you wish them to be. It is up to you how you transform them and what image you impose on them. This is why I have called this chapter "Room Sets." City spaces can be likened to a theater stage that only manages to contribute to the story of the play once it has been dressed.

Set with its eighteenth-century overtones this stage takes you a step back in time. It has an air of cultivated refinement and suggests a place where even grabbing a simple snack would feel as if you were dining in grandeur. Yet the informality of its bare floorboards and iron "campaign" seat still confirms it as an essential living area where you can relax and unwind, protected from the outside world, not to mention it being a fascinating backdrop and conversation area for all guests who come to visit.

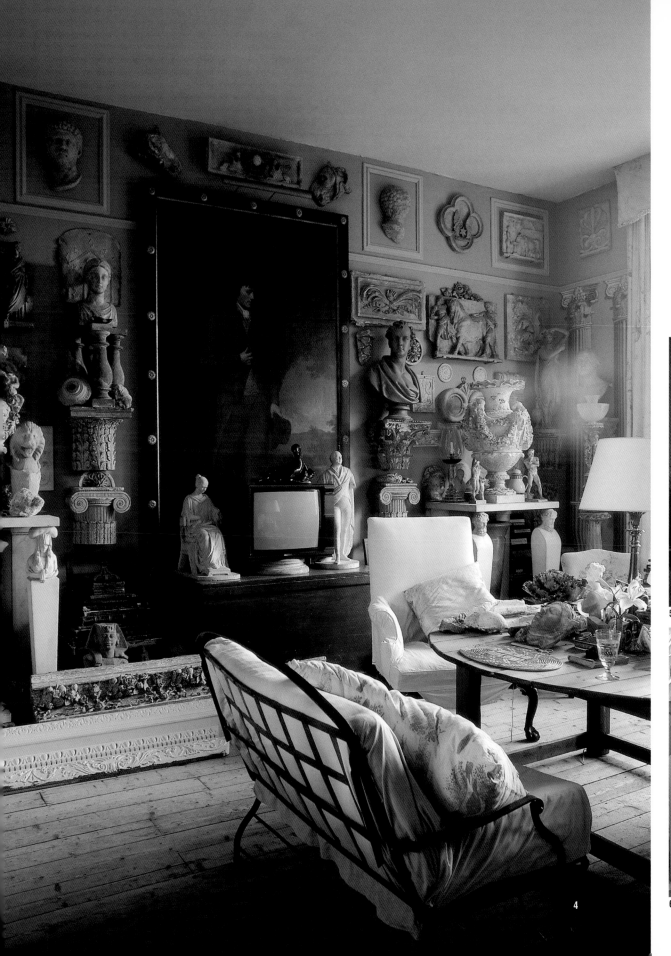

5

6

4

KITCHENS

ALTHOUGH KITCHENS NEED TO BE FUNCTIONAL AND PRACTICAL, THIS DOES NOT MEAN THAT THEY HAVE TO BE DULL AND BORING. THERE ARE AS MANY POSSIBILITIES FOR CUSTOMIZING YOUR KITCHEN AS THERE ARE FOR OTHER AREAS OF YOUR HOME.

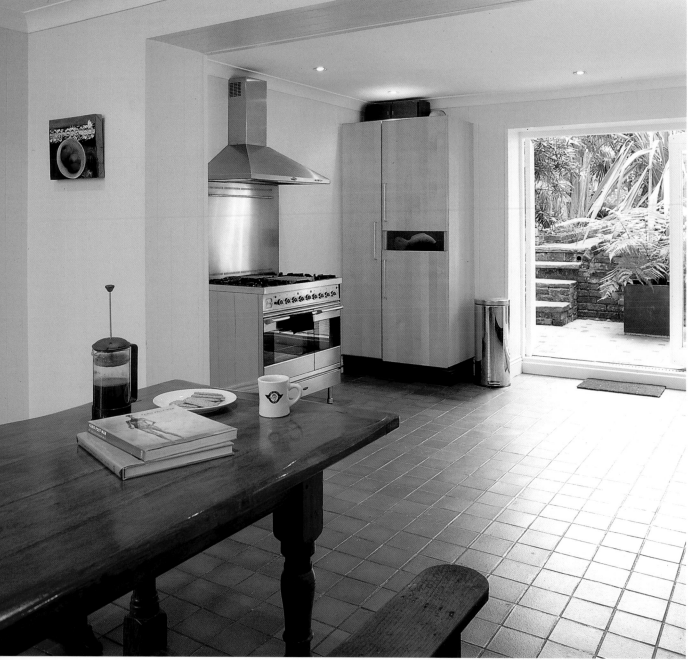

1 3

2

MODERN RETRO

For small urban spaces, the kitchen area might only be a short length of wall within a dining area, or a tiny annex no bigger than a broom closet. It is here that the fitted kitchen comes into its own. Compact, and making the most of available wall space from floor to ceiling, fitted kitchens can be tailor-made and compartmentalized to serve every aspect of culinary activity. They can also be ready-made and prepackaged, just waiting to be emptied out of a box and reassembled. It is this latter variety that most people turn to when working to a shoestring budget, but this does not mean you have to end up with a bland and uninspiring kitchen.

With a little extra resourcefulness and a few well-chosen accessories, you can customize it and make it unique. This small studio apartment example proves what it is possible to achieve without much outlay. Before you despair over the lack of room you have to work with, however, think on this positive note: small space equals small cost. Wall paint, flooring and countertops are all going to cover such small surface areas that the money you will save means you can afford better-quality materials than you thought. Opt for details that you really like rather than choosing the cheapest. This small effort will make all the difference.

Although this example is essentially a clean and modern-looking kitchen, there is a retro undercurrent to it. This has been formulated by the owner's choice of classic-designed details and his tasteful mixing of contemporary materials. The end result is something between a New York delicatessen and a classic American diner. This effect is mainly caused by the 1930s-style globe-light fixture, of the type that you so often see hanging from the high ceilings of American diners. If you like this look, then here is your inspiration source. Research it, soak it up and seek out those definitive details.

As you can see, the owner has incorporated some standard ready-made units, but these have been offset by an assortment of freestanding storage units to one side, and an attractive shelving system above. These metal-bracket and plate-glass shelves again have a nice retro feel about them, with their similarity to those found on 1930s bathroom units that also incorporate mirrors and holders for toothbrushes. Plate glass, with its aqua color that turns icy when sandblasted, is a refreshing material to use in a modern kitchen. Its clever use here means that, despite its mainly being covered by crockery, the translucent areas that are uncovered allow light to pass through, preventing heavy shadows from forming beneath each shelf.

Besides shopping around downtown stores for modern fixtures that suggest they have been based on original classic designs, look out for Art Deco examples at flea markets and salvage yards. Think imaginatively and always look at bathroom fixtures in a new light, with an aim to incorporating them into your kitchen.

Another good source for kitchen bits and pieces are stores that serve the restaurant and catering industry. Here, not only will you find the most robust crockery and glassware but also pieces that look as though their design has not been changed since the 1950s.

[1] This wall-rack system represents an excellent alternative to cabinet drawers when storage space is limited. Cooking and eating utensils share the same niche and provide the room with an industrial-canteen feel.

[2] The clever use of open shelves rather than a cupboard on the wall means that the kitchen receives as much daylight as possible from the adjacent windows. A combination of frosted-glass shelving and white crockery makes an attractive feature.

[3] A classic 1930s-inspired ceiling-light fixture gives the kitchen its New York deli hallmark. Look for similar fixtures in architectural salvage yards and antique-lighting stores, or shop around for good reproduction examples.

[4] Modern materials, clean cool colors and an innovative use of space have turned a small annex of a studio apartment into a stylish and practical kitchen area.

[5] Choosing the right accessories can help enhance the look you desire for your kitchen. For instance, this traditional waffle-weave dish towel adds a distinctly retro nuance.

[6] Fashionable industrial-style materials and finishes are now available from most domestic-flooring retail outlets. The relief design on this example gives it a 1960s "space-age" look.

[7] Efficiency is the name of the game if your urban space errs on the small side. A sink cover doubles up as a chopping board and provides extra countertop surface area.

5

6

7

[1] Internal windows allow dark rooms or corridors to borrow light from brighter adjoining areas, as well as creating interesting views into other parts of the home.

[2] Using a garden wall-planter for kitchen utensil storage is an imaginative use of a junk market find.

[3] The predominant use of white-washed timber in this riverside warehouse apartment sets the tone for a galley-like kitchen area. The breakfast bar in the foreground serves a dual purpose, providing extra storage space inside it.

[4] Wooden plate racks automatically lend an old-fashioned, rustic feel to a kitchen. Besides their main function as a drying device, they also serve as a crockery display unit. This one shows off a row of vibrantly colored dishes.

[5] A touch of metalwork reassures us that this apartment is an urban one. All materials can be associated with a style or mood, which they lend to a space when introduced into it. Raw metalwork suggests a gritty industrial feel.

[6] For a handmade, less perfect look to your kitchen, keep an eye out for found materials and objects. This builder's scaffolding plank was salvaged from a dumpster, given a coat of watered-down emulsion and turned into an intriguing kitchen shelf.

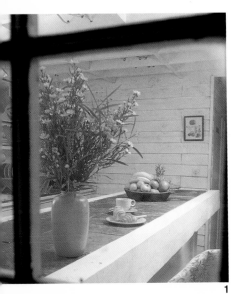

1

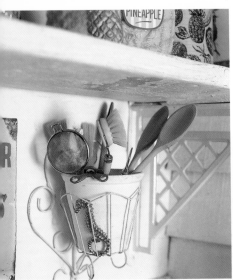

2

 ## WAREHOUSE RUSTIC

Just like every area within your home, the kitchen should be another extension of your personality. Customizing an existing kitchen that you inherit when you buy your home is one way to make it stand out from the crowd. Another way is to remove the old kitchen completely and start afresh with ideas tailor-made to suit your own needs and specifications. This is the best way to end up with a totally one-of-a-kind style of kitchen that you will not see in any magazine or trade advertisement.

If money is no object, one route to take is to employ an architect or interior designer, and to work with them to create a really special kitchen for you. It is equally possible, however, to create a unique kitchen on an exceedingly small budget where you are your own interior designer. A lack of funds can be easily made up for with a little imagination and a lot of resourcefulness. This kitchen area in a warehouse loft apartment is a prime example. It is built within a three-sided enclave at one end of the warehouse space, being left open along one side to allow light from the opposite end of the apartment to flood into it. To maximize the available light, the entire kitchen area has been painted white, keeping it as bright and airy as possible.

The curious ceiling structure is actually formed by the timber joists to a mezzanine level above, and is one of the features that lends a ship's-galley quality to this kitchen. This is not the only nautical reference within the kitchen's design. To maintain the timbered look of the warehouse apartment, all the kitchen walls, and the side panels of the breakfast bar, have been clad in clapboarding. This conjures up an image somewhere between a Californian beach house and an old fishing boat.

For such a striking effect, it is important to note that the cost of creating this individual look was a fraction of what a brand-new mass-produced kitchen would have been. The overlapping timber planks, normally used for shed construction, were bought unplaned from a lumberyard and fixed to a skeletal timber framework. They needed only a light sanding before being painted, so that they remained fairly rough and textured to reinforce the rustic impression of the kitchen.

The other main cost was that of the African-slate floor tiles used for the breakfast-bar top. Obviously, these tiles are meant for floors, but their use in this case to create an antique-looking counter surface illustrates what I mean by being resourceful. Always consider uses other than the obvious when choosing materials, fixtures and fittings. Thinking this way will make your kitchen so much more original.

Another interesting detail to point out about this kitchen is the fact that the louvered cupboard doors were bought ready-made from a downtown chain store. Once fitted and painted, they blend in perfectly with the clapboard walls. As this proves, resourcefulness is not only about finding or salvaging something for free but also about understanding how and when to mix the old with the new, and the bought with the found, in order to achieve the best result for the minimum cost. Being economic is not about skimping. It is about being creative and imaginative with your materials.

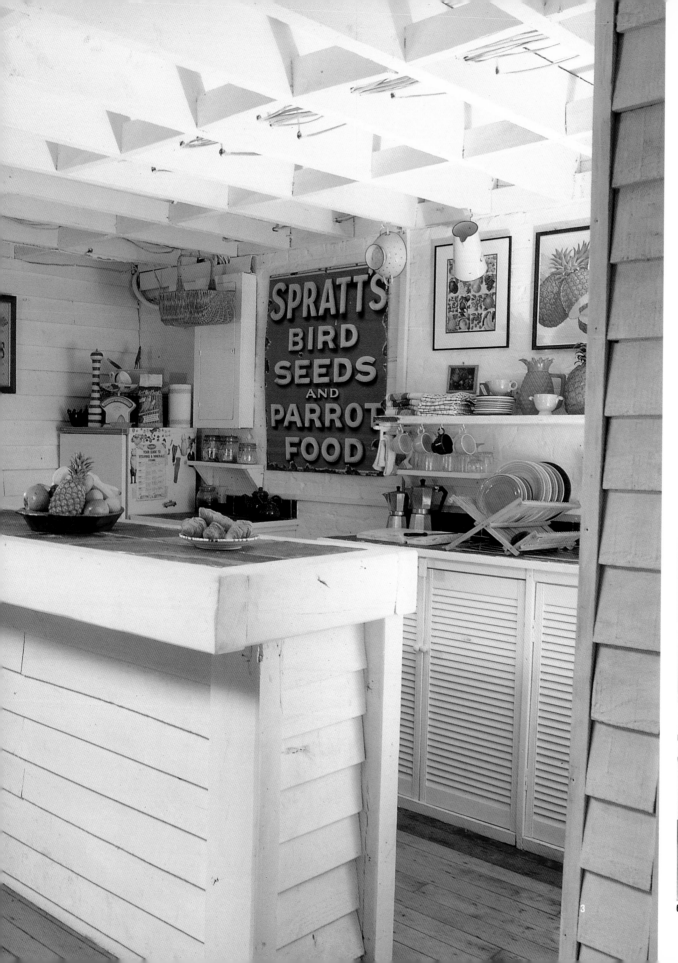

4

5

6

3

BEDROOMS

A BEDROOM IS USUALLY A PRIVATE AND INTIMATE SPACE IN OUR HOME, A SAFE HAVEN TO END THE DAY AND THE FIRST SIGHT THAT GREETS US AT THE START. IT SHOULD BE COMFORTABLE, SOOTHING AND A PLEASURE TO SPEND TIME IN. IT SHOULD ALSO BE INSPIRING.

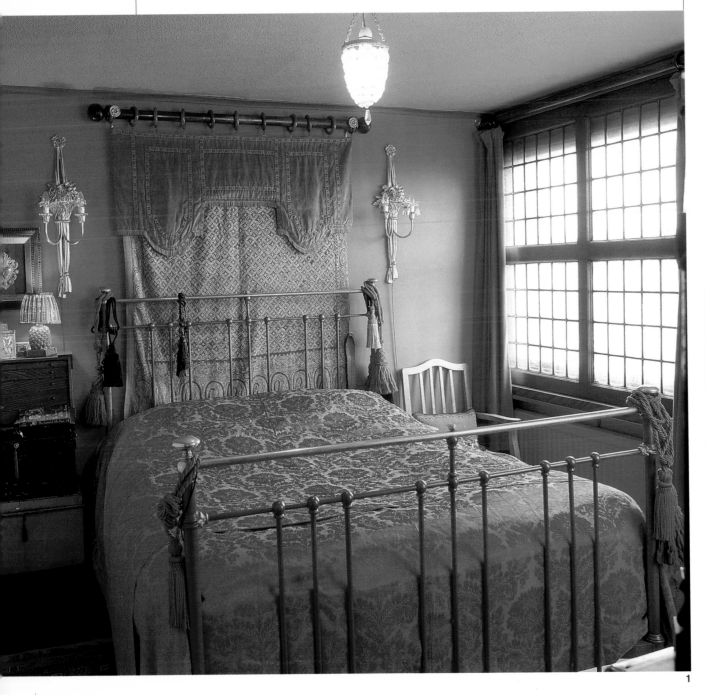

1 2 3

OPULENT PERIOD STYLE

A bedroom can represent an element of escapism and be the fantasy room of your choice. Your inspiration for it might come from art, historical literature, galleries or museums, or even from visiting stately homes where you can admire bedrooms from another era. From French chateaux to Venetian palozzi, the world is your oyster when it comes to sources of inspiration.

This example is a step back in time to an age of brocades, damasks and candelabras. It reeks of decadence and grandeur, evoked mainly by the sumptuous fabrics and bold use of red and gold. These regal colors are not for the faint-hearted, but, as they say, if you are going to do something do it in style.

The real beauty of this bedroom is that, despite its overwhelming grandeur, the budget was surprisingly low. It is the way in which you combine different elements that will ultimately render the look, not how much you spend. All the details in this bedroom were found by chance when the owners were scouring flea markets, junk shops and tag sales with the look they desired firmly ingrained in their minds. The internal "false" window that also acts as a form of double glazing was found in a dumpster outside an old office building that was being renovated. The bedspread and wall-hangings, which were originally curtains, were bought at a tag sale and retailored. Their rich colors and designs were perfect for the room.

Besides cost, the other fascinating aspect of this interior style is that, although it gives the impression of belonging to a country house that is several hundred years old, it is in fact in a modern apartment building. Only when you look out of the window is the deception revealed. Creating such an illusion in the center of the urban jungle is a task you can easily undertake.

Start collecting reference material of aspects you like, whether from another era, another country, or both. This could include clippings from magazines, postcards from galleries and museums, fabric swatches from department stores, and even sketches from your travels. Start to build up a picture in your mind of what to look for in the way of furniture and accessories when you are out exploring junkyards and flea markets. You do not have to be too literal in the details—it is more the feel or atmosphere you are seeking than a carbon copy.

This example draws on many sources from Venetian Renaissance paintings, religious iconography, baronial halls and Elizabethan manor houses. The result is a rich tapestry of color and textures that turns retiring to bed into an almost ceremonial occasion.

[1] This bedroom in a modern urban apartment was inspired by the opulence of the Venetian Renaissance. A mix of sumptuous fabrics and gilded surfaces elevates the room from a mere place to sleep into a stately experience.

[2] A nineteenth-century Bavarian carved armchair suggests a throne for a regal-looking bedroom. The luggage trunk stored beneath it provides useful storage space.

[3] The effect that a window style can instill on a room's interior is remarkable. A plain, contemporary window has been double-glazed using an original 1930s office window—this immediately enhances the antique quality of the room.

[4] Rich and exotic vintage fabrics found at flea markets and tag sales set the tone and color scheme for the room. These examples have been hung on the wall to create a dramatic headboard, reminiscent of four-poster bed drapes.

[5] New use for old. A cleaned-up toolchest is now used as a storage unit for a collection of vintage jewelry.

[6] Elegant gilt light fixtures like these are the final opulent touches that will make the room. Reproduction examples will create the same effect as the real thing at a fraction of the cost.

4

5

6

INDUSTRIAL CHIC

When deciding what interior style you would like to create in your bedroom, there is one main and unavoidable feature that you will have to consider—the bed. This is a crucial decision, for a bed virtually dominates the space you designate as your sleeping area. In fact, a typical double bed can practically steal up to a quarter of your living space if you live in a small, urban studio apartment. An alternative to this is the sofa bed. The beauty of this type of furniture is that it can revert back to a more functional piece of furniture during the day rather than taking up the dead space a normal bed occupies for up to two-thirds of its existence.

If, however, you prefer to retain a resident bed in the room, then you need to consider how it will work. After all, there is no escaping the fact that the bed is normally the first thing your eyes meet when you enter a bedroom. The options here are either to make a feature of your bed, turning it into a splendid piece of furniture to be admired and envied, or to make it as inconspicuous as possible.

In this minimalist bedroom, the bed successfully melts into the background and becomes just another surface and another texture within an all-white room. It is low to the ground, and features no frills, posts or headboard. Most of all, however, its whiteness helps it "bleach out" into the rest of the room, thus becoming less obtrusive and no longer a focal point.

White is the cleanest look you can have, and when combined with plenty of light, as provided by these floor-to-ceiling windows, you can end up with a heavenly effect where plumped-up comforters appear like floating clouds, making the bed highly inviting.

Although we think of all-white rooms as contemporary, part-and-parcel of modern urban living, interior decorator Syrie Maughn was in demand for her "white room" decoration schemes back in the 1920s. Other white rooms appeared as Hollywood film sets in the early 1930s to complement the platinum-blonde hair of Jean Harlow. Back then, white rooms were seen as the epitome of glamor. Today, they are the ultimate in sophistication, an adult approach to interior design where the frivolity of color is banished.

What the absence of color does do, however, is highlight the textures of surfaces within the room. For this reason, greater emphasis should be put on the materials used. This example combines the smooth, glossy finish of the walls, the coarseness of the concrete ceiling, and, of course, the inviting soft curves of the comforter and pillows on the bed.

To accentuate the clean look of the white decoration scheme, any excessive furniture, accessories and other details that would threaten the minimal look have been avoided. The walls are paneled from floor to ceiling to create an unbroken surface, adding to the streamlined look of the room. This paneling actually hides ample storage, one of the other main criteria to consider when designing your bedroom.

If you would like to create similarly invisible storage space for your bedroom, allow for the fact that it will noticeably shrink the room, especially when applied to two or more sides of the room.

To maximize the lightness of your space, avoid curtains and try to keep the window frame uncluttered and spartan-looking. Blinds are neater and give cleaner lines to a room. The owner of this bedroom uses just a movable screen in front of his window, but only choose this if you are capable of sleeping in full daylight or you are an early riser during the summer months.

A detail that always looks fantastic in a totally white room is a piece of plain, clear glassware filled with water. A vase or jug with a single stem is enough. The crystal effect of the water as it refracts and reflects all the bounced white light in the room will add the ultimate crisp touch to a dreamy white room like this one.

[1] Crisp white bed linen and white-paneled walls give this industrial-style bedroom a fresh, clean look. Furnishings and accessories are kept to a minimum so as not to spoil the geometry of the space.

[2] A retro telephone chosen for its tactile and sculptural qualities adds an unpredictable touch to a very modern-style bedroom.

[3] Glass bricks used as a partition wall allow plenty of light to flood out of the bedroom area and into the hallway. Notice how this vertical strip of wall accentuates the height of the apartment.

[4] Graphic shapes dominate this bedroom—even the bedside lamp that displays distinct Bauhaus styling.

2

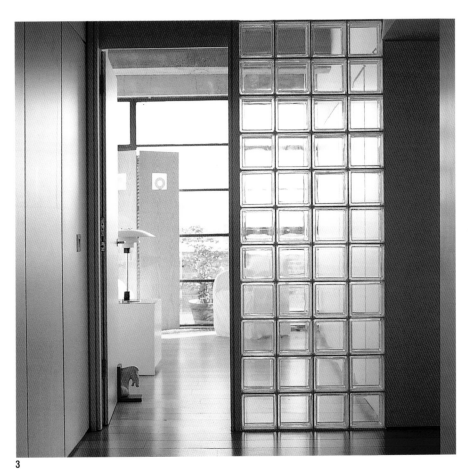

3

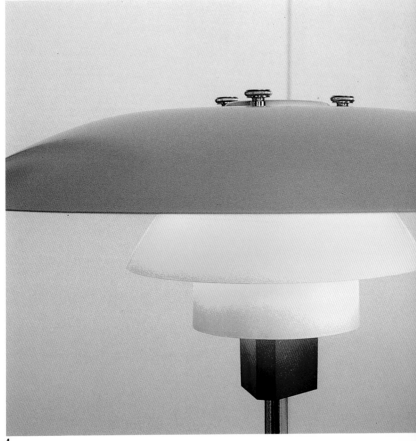

4

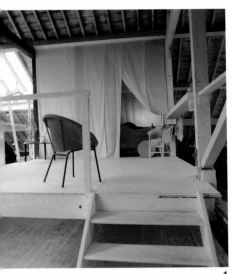

[1] A draped-back curtain reveals an alluring bedtime retreat perched among the rafters of this warehouse-loft apartment. The open structure of the staircase and mezzanine rails allows plenty of light from the skylights to filter through the sheer fabric.

[2] Simple but effective, a collection of eclectic furnishings adds texture and shape to an all-white space, while exhibiting hints of Surrealism and Parisian Bohemian living of the 1950s.

[3] Objects taken out of context, like this wicker mannequin from a lingerie shop, can create intriguing and unconventional details in a room. This one also adds a distinctly feminine touch to the bedroom area.

[4] Long lengths of white muslin form the "walls" of the bedroom area. This innovatively transforms one end of the mezzanine level into a soft and inviting nocturnal cocoon.

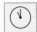 WAREHOUSE RUSTIC

Bedrooms are the ideal spaces to turn into romantic hideaways. They are places where we can indulge ourselves and turn moments of our life into special occasions—for example, lying in on a Sunday morning and reading the papers over breakfast in bed, or returning early in the evening to read a book or watch TV from the confines of a down comforter. None of these decadent treats costs anything other than making your bedroom environment as pleasurable as it possibly can be. This open-plan warehouse loft does just that with a discreet and feminine example that was created in a matter of hours after a visit to an Asian fabric store.

The bedroom area is entirely defined by overlapping lengths of white muslin, giving an ethereal and tent-like feel to the interior. These fabric "walls" provide a versatile solution for defining a bedroom area, which can be applied to virtually any other urban dwelling. It would particularly suit a studio apartment where there is no separate bedroom and the bed is forced to share the common space.

In this warehouse bedroom, the fabric drapes hang down to form a seamless white canvas that not only hides the bed and storage drawers on the inside but also provides a clean blank surface on the outside to enhance the minimal open-plan landscape of the mezzanine level. During the summer months, these fabric walls can be draped back to make the space more cool and airy. Although a similar style of bedroom could be achieved with other fabrics, the use of sheer fabrics prevents the interior from becoming too dark and cave-like when the drapes are down.

This example shows how quick and easy it can be to create a separate space for your bed fairly cheaply. More importantly, it illustrates how the temporary nature of fabric manages to continue the illusion that the room is still connected to, and part of, the main open-plan arrangement. Besides its functionalism and practicality, it conveys a beautiful aesthetic quality that is serene and timeless. This is an important factor to heighten the pleasurable aspects of your bedroom. Make sure the bedroom you create has a mood attached to it, and does not rely on looks alone. Incorporate soft lighting from table lamps, or "reflected" light off the ceiling from wall sconces.

Throughout this book, I have described the homes and interior styles of my selection of intrepid urban dwellers with references to designers or artistic movements in history. Such recognizable genres of decoration or "period" styling provide a visual shorthand that sidesteps the need for long-drawn-out descriptions. It also invariably gives us a more definitive picture of their inspiration sources.

Here, the combination of the bedroom location beneath the eaves of the vast warehouse roof and the retro furniture and eccentric accessories conjures up the Bohemian spirit of a Parisian artist's garret of the 1950s. The large, empty rococo picture frame, the lingerie mannequin and the skylights all add to this romantic notion. Look for similar ideas that you can reinterpret to transform your bedroom into an equally surreal and magical experience.

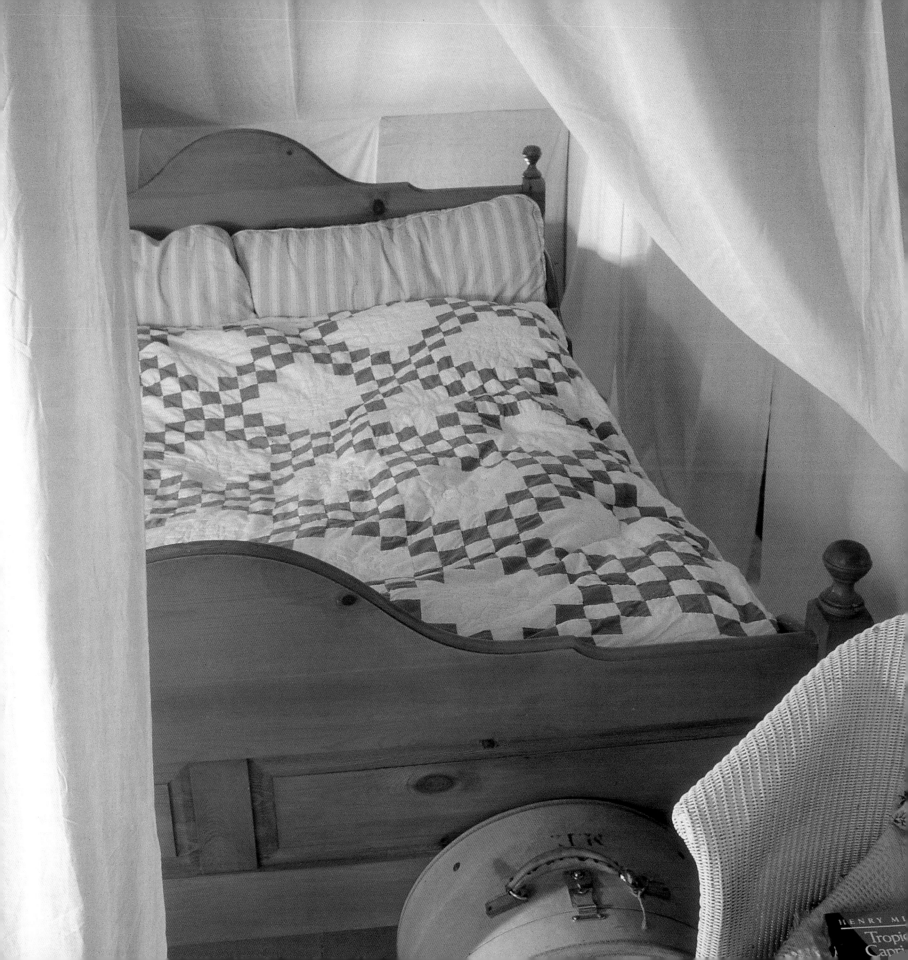

⊕ CLASSICAL PERIOD STYLE

Besides the color scheme and lighting of your bedroom, it is the furniture and furnishings that you add to it that will provide the ultimate style you are seeking, especially if it is a period one. Do not think that designing an authentic period style is something you can achieve in a day or two. It is not. Unlike with a modern-styled interior, you cannot just pop downtown and buy all the pieces off the shelves. A period style requires more patience. Only time will allow you to amass all the individual, quirky and eccentric artifacts that will help establish the right atmosphere of a bygone era. This might require hours, if not years, of foraging in antique stores and junk shops, visiting flea markets and tag sales, and frequenting many a city or country auction house.

The idea of your bedroom evolving over years might sound daunting, but the reward for such an interior stems from the hunt for those pieces that you know will look right but have yet to find. Then there is the sense of chance and luck that accompanies the chase, knowing that you might come across what you are looking for at any moment. In this bedroom, for instance, it has taken many years to accumulate the antique and comfortable layout that you see now.

The Victorian mahogany bed is the main piece of furniture of the room, which, thanks to its bold and heavy outline, manages to stand its ground among the busy collection of prints, pictures and classical medallions that cover the majority of wall space. Remember that a bed is like any other piece of furniture in that it will portray the popular design style of its period. In English design, for instance, four-poster beds epitomize the Elizabethan through to the Georgian periods, Gothic and heavy mahogany styles the early to mid-Victorian period, and daintier iron and brass beds the late Victorian to Edwardian periods.

This mahogany example has been given a lighter look by covering it in a white embroidered bedspread from the nineteenth century. Bedspreads are a useful device in any bedroom as they can unite the large expanse of a bed with the rest of the bedroom interior through color, pattern, texture or all three. It doesn't necessarily have to be an original, custom-made bedspread. Any beautiful vintage or antique fabric, even old curtains, can easily be transformed into a bed-covering to dramatic effect.

The advantage of a period-style bedroom is the mellow palette that comes with period objects and furnishings that are worn and weathered from being handled and knocked about over generations. This automatically creates an "aged" look to a room that is warm and comforting, ideal for a bedroom.

You can complement this palette by painting your walls or ceiling in a color from the "heritage" range now produced by many of the leading paint manufacturers. They even supply a suggested guide as to which colors best suit a specific period.

This style of bedroom might require more work and patience to get right, but once you sit up in bed and survey the results you will definitely decide it was worth it.

2

3

[1] An ornate Victorian mahogany bed nestles among an enthusiastic collection of prints, paintings and objets d'art. The curtains are secured with tie-backs for effect in summer but serve a practical purpose in winter, providing extra insulation around the window area.

[2] Bedspreads are a good way to "dress" the bed and tie it into the rest of the room's interior. This antique embroidery example gives a luxurious yet understated texture to the period styling of this bedroom.

[3] A modern door has been given a classical makeover by replacing the original glass panels with relief plaster ones featuring Grecian ewers.

[4] For a true period ambience, furnish and accessorize with pieces that reveal their age in some way. The chipped and flaking paint on this small picture frame adds invaluable historical character to a wall-mounted collection.

4

BATHROOMS

SITTING IN A HOT BATH, SCENTED WITH ESSENTIAL OILS OR PERFUMED SALTS, IS THE IDEAL WAY TO RELAX AND UNWIND, AND YOU CAN DESIGN THE IMMEDIATE SURROUNDINGS TO ENHANCE THIS EFFECT. EVEN IF YOU ONLY HAVE ROOM FOR A SHOWER, A BATHROOM OUGHT TO FEEL LUXURIOUS.

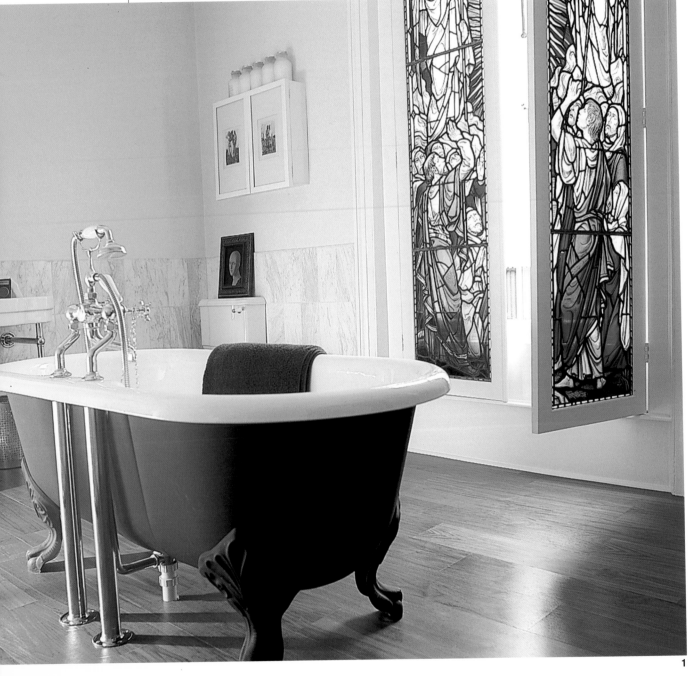

2

3

[1] By placing it center stage, the sculptural qualities of this Victorian-style roll-top bathtub can be fully appreciated. Equally dramatic are the ecclesiastical-themed stained-glass panels that have been turned into unique window shutters.

[2] The chunky geometric shapes of Art Deco suit a modern-style bathroom. Reproductions of original 1930s and 1940s designs are made today, so that fixtures similar to these can be bought as new.

[3] Using stained-glass panels as window shutters is an inspiring and imaginative feature of this bathroom. Hinging rather than fixing them not only gives them versatility but also makes them a tidy alternative to curtains or blinds.

1

Bathrooms on the whole need to be practical and simple—easy to clean, with surfaces that will not get ruined if they get wet or steam-drenched. Whether it is actually a bathroom with a bath or one with just a shower will be a matter of available space in your apartment.

This modern-style bathroom makes a very luxurious statement with stunning features such as the generous-sized, ornate bathtub and the jewel-like stained glass. Despite the very modern minimal approach to its layout, these classical elements prevent the space from becoming too cold or unfriendly.

Fixtures and fittings like the roll-top bathtub and the chunky geometric sink are reproductions of vintage designs, and will add an elegant period feel to any bathroom. Original bathroom fixtures like these can be found in architectural salvage yards, and although they cost less they often require more work to install than brand-new equivalents. Faucets will probably need their sealing washers replaced, and the bath itself may even need re-enameling. Watch particularly for cracks around the drain area. This might mean that the drain is corroding, and therefore removing it for resealing or replacing it completely could result in large pieces of enamel flaking off. Consult a specialist before you buy.

A bath that is as characterful and sensuous as this example deserves to be seen at its best, so the center of the bathroom is the ideal position. Its beautiful sculptural qualities can then be admired from all angles. Placing the bath on a dais in the center of the room would accentuate its features even more. Then bathtime really would feel special.

An important factor to remember if you wish to site your bath in a central position is that you will invariably be able to see the plumbing. Here it has been tastefully disguised by sheathing it in chrome tubing so that the pipes do not detract from the room's modern, clean look. Another practical aspect to note is the fact that the lack of tiling or wall surface immediately around the bath will mean that water splashes directly onto the floor. The floor must be well sealed, if it is wooden; and, to avoid any accidents or slipping when you get out of the bath, make sure you have a rug or mat to stand on.

They say cleanliness is next to godliness, and in this bathroom this is particularly true. This ecclesiastical stained glass, found at an architectural salvage yard, has been utilized in a very imaginative way. Rather than have the glass set into the main window as a permanent fixture, it has been mounted in individual frames and hinged, so that the frames perform as shutters. Thus, access is allowed to the normal main window behind, for both ventilation and additional light when needed. The effect, however, when these shutters are closed, whether for privacy or merely decorative purpose, is magnificent. They certainly add an enlightening spiritual overtone to the room.

[4] A stylish white bathroom cabinet also serves as a miniature display unit. Prints and etchings can be slid in and out via the top edge of the cabinet doors, allowing for an occasional change of scenery within the room.

4

1

2

[1] Starfish and scallops cemented around the door handle make entering this bathroom a special event. Decorating with seashells like this is reminiscent of the grottoes created as garden follies for eighteenth-century country houses.

[2] Mosaic floors can be more imaginative and entertaining than traditional tiled floors. This charming example features an assortment of sea creatures and seashells among graphic rococo scrolls.

[3] A one-off shelving unit acts as a storage and display area for exotic jewelry, toiletries and ornaments. The pale pastel colors maintain the fresh, clean feel of the bathroom.

[4] Simple little touches can transform a plain bathroom into a nautical wonderland. The trail of encrusted seashells around the edges of the walls and mirror leads your eye into and around the room, as does the winding scroll of the mosaic floor.

3

GROTTO STYLE

Do not be disheartened if you inherit a bathroom not quite to your liking when you buy your next abode, particularly if you have blown your entire budget and cannot afford to replace it. Consider customizing what you are stuck with. On a very limited budget, it is possible to revamp and modify what you dislike. You may not be able to afford to change the main bathroom fixtures, but you can do a few things that will take the focus away from them. As you can see from this example, just a few little touches can make all the difference. In this case, such touches have turned a plain white bathroom into a dainty and beguiling haven. The overriding theme here is nautical or grotto-esque. Grottoes were immensely popular in the late eighteenth century, created as follies or buildings for amusement that were incorporated into the landscaping of country-house estates. These, along with "faux-ruins" and Gothic towers, were built to entertain the owners and their guests as they stumbled across them on their strolls around the estate. Grottoes were lined with shells and natural-faced rock, and often featured a classical marble or stone statue reclining in a man-made rock pool.

This more discreet bathroom interpretation of a grotto has assorted shells and starfish cemented along the peripheral edges of the wall tiles and mirror, and even around the door handle. Their irregular arrangement is reminiscent of the cluster-like formation with which barnacles attach themselves to boat hulls and anchors. This has the effect of transforming the flat and uninteresting walls, giving them a "frothy" energy that brings the whole room to life. The effect is echoed in the floor treatment, where a well-designed mosaic has images of shells and sea creatures swimming among swirling waves. This scrolling design also harks back to the eighteenth century when the rococo style was at the height of its popularity.

These two small modifications make this bathroom a pleasure to be in, and have been achieved with very little outlay or upheaval. Both the shells and the broken tiles for the mosaic floor can be resourcefully found for free. Tiles are often thrown out by builders when they have finished renovating a property and find they are left with a surplus of materials. Look in dumpsters near building sites and start collecting. Alternatively, for a small outlay, broken tiles can be bought cheaply from tile salesrooms.

Depending upon how exotic you want your sea shells, the majority can be picked up off local beaches and even river estuaries. If shells are hard to come by, then consider other "found" materials that could be turned into similar borders around your bathroom. Pebbles of varying sizes, or pieces of driftwood overlapped and interlocked, could make fascinating textures in an urban bathroom. Be careful, however, not to violate any local restrictions regarding the removal of such items.

For additional decadence in your bathroom, accessorize with natural sponges, chunks of pumice stones, jars of bath crystals and clam shells for soap dishes. Do not forget to add the lighthearted details included in eighteenth-century grottoes. You might not want a reclining sea-god in your bathroom, but how about a ceramic mermaid?

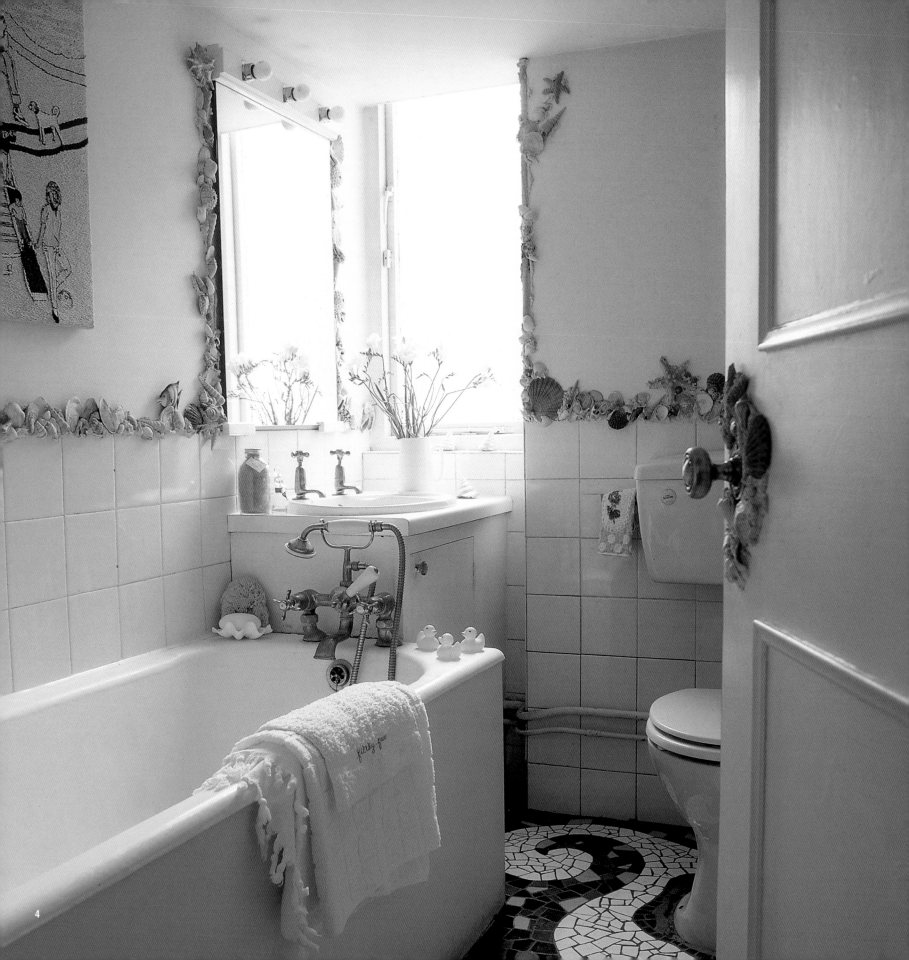

GLOBAL STYLE

If clean, fresh and minty is not your kind of flavor for a bathroom, this spicy and mysterious global bathroom provides an alternative to the all-white look. It is a bold approach, but one that is far more evocative than the traditional. The predominant use of tiling and the choice of strong colors immediately sets a Middle Eastern tone, with images of Moroccan temples and secret courtyards brought to mind.

This style of decoration, with the use of ceramic tiles, seems very appropriate for a bathroom. The Islamic culture incorporates mosaics and tiles in much of its architecture, both internally and externally, as a cooling and resistant surface, well suited to hot, dry climates. Most of the tile designs are geometric, so the diagonal checkerboarding used in this bathroom is very fitting.

Instead of having tiles just as a border around the top edge of the bath, in which case the wall above invariably gets splashed and starts to look grubby within a year, this example continues the tiling all the way up to the ceiling. Thus the whole wall is splash-resistant, easily cleaned and consequently smarter-looking for longer. In fact, covering bathroom walls with glazed ceramic tiles cuts down the need to redecorate for years.

Particularly attractive is the way the tiling continues down to the floor and around the sides of the bath, giving it a sunken-bath feel. Lying back in a tub of hot steaming water, you could quite easily believe you were in a Turkish steam room. It is a good sign that you have got your interior styling correct when you have turned the concept of washing yourself into one of pampering yourself.

To maintain the "casbah" atmosphere, use soft lighting. For ceiling light fixtures, choose the pierced-metal lantern type. These hold back most of the light from the bulb, allowing it to emerge only through the shaped, cut-out holes around it, which then project beautiful illuminated patterns across the ceilings and walls. Have a more direct light over the mirror and sink for practical purposes. Diffuse the harsh rays of daylight, which will destroy the moody ambience you are after, by either draping sheer fabrics across the window or adding a blind of some kind. Venetian blinds are very practical in that you can adjust the level of lighting, but they are not nearly as romantic as floaty fabrics. Do not hang curtains. Keep the window frame simple and less domesticated.

Finally, to accessorize your splendid bathroom, use lots of antique-looking metalwork, particularly brass. Brassware is very popular in Middle Eastern countries. Details like soap dishes, shaving mirrors, sponge racks and candleholders will all add to the exoticness of the room. Old, secondhand pieces are best, because they will already have a nice patina of age to them. But because it is also possible to age brass artificially, you can always buy new examples and modify them.

[1] Tiles and mosaics are extensively used throughout Islamic countries as a form of architectural decoration. The continuation of the wall tiles down and around the sides of the bath re-creates the look of a Turkish steam room.

[2] This bathroom wall proves that tiling can be both practical and visually appealing. The dramatic effect of this example is produced simply by the choice of rich colors used in the checkerboard design.

[3] To add atmosphere to a bathroom, try diffusing the incoming daylight with blinds or sheer fabrics. The fabric draped over this window gives a soft blue tint to the room, which slightly cools the hot and spicy wall colors.

[4] Accessorize a bathroom with exotic details. A simple arrangement of hand-made soaps in a bowl can make a bold statement.

2

3

4

[1] Everything has been carefully considered and thought out, including a steam-room bench with dry towels always at hand on the adjacent heated towel rail.

[2] A slab of concrete provides plenty of luxurious countertop space around the bathroom sink. The juxtaposition of the coarse stone against the smooth white porcelain accentuates their textural differences.

[3] To maintain the uncluttered look, bathroom fixtures and fittings are kept to a minimum. This single, sleek-designed faucet performs all the functions that normally require two.

[4] The minimalist styling and the use of hard, nondomestic materials make this shower room extremely functional. Notice how the slatted floor allows for quick water drainage and provides a non-slip surface.

INDUSTRIAL CHIC

For many urban dwellers, the size of their living space is the deciding factor for their interior design style, and the contents they incorporate within it. Bathrooms and kitchens are the areas that suffer most when space is limited, forcing resourcefulness to be at its keenest. In the bathroom, for instance, the luxury of a bath will often have to be forfeited in favor of a more compact shower unit. This does not mean that a shower is second best, only that it is more practical in certain circumstances. Even when space is not a problem, a shower can still be a more practical solution, especially for people who have a fast and busy lifestyle. Of course, the choice of a shower over a bath may be simply a matter of personal preference.

This industrial-style bathroom features a shower where space was not an issue but efficiency was. Stylistically, it complements the industrial loft apartment that it is situated in, but its design is as much functional as aesthetic. It is decorated in a raw and minimalist fashion, cleverly combining a well-chosen selection of nondomestic materials, such as frosted plate glass, concrete and chrome, to create a suitably gritty, urban feel in the room. In some ways, you might look at this bathroom and think that its stark and barren appearance does not belong in a home, and that its apparent lack of comfort suggests hardship rather than pleasure—that is, until you start to realize that its beauty lies within its extreme practicality, and that its simplicity is in fact a great luxury.

The interior of the shower room is lined with what looks like concrete, but is in fact a material used for lining swimming pools. Its surface is smooth and flat, so there are no grooves and cracks for soap and mildew to accumulate in, as there are on traditional tiled walls. The showerhead and controls, like all other fittings, are pared down to the absolute minimum, thus enhancing the clean, neat look of the shower's interior. The recessed shelf space for toiletry storage also adds to this effect.

The floor is wooden-decked throughout, allowing water to drain straight through the gaps between the slats, so you will not have to stand in pools of soapy water or slip as you get out. Even before you get out, the decadent size of the shower has allowed for the provision of a small bench where you can rest and dry yourself with lovely warm towels straight off the heated rail at your side.

Simplicity continues beyond the shower interior to the plain frosted plate-glass boundary walls. When the door panel is closed, the shower is totally obscured from the rest of the bathroom, so that privacy is assured, but its internal lighting is still allowed to shine through. This backlit wall further enhances the aesthetics of the bathroom by providing a soft-ambient, aqua-colored glow.

This very urban example of a bathroom is a model of functionalism in which you can recognize its luxurious qualities. Its practicality and low-maintenance design makes it ideal for a time-saving and more hygienic style of living—essential for today's fast-moving lifestyles.

WORKSPACES

GOING TO WORK HAS A NEW MEANING TODAY, AS MORE AND MORE PEOPLE ARE SETTING ASIDE SPACE IN THEIR HOMES FOR AN OFFICE. THEY HAVE DISCOVERED THE GREAT FREEDOM AND FLEXIBILITY THIS CAN LEND TO THEIR LIFESTYLE, PROVIDING IT IS DONE IN A PROFESSIONAL AND ORGANIZED WAY.

1

[1] An office set out in an industrial loft space mixes antique furniture with retro lamps for a permanent low-tech look. Computers and state-of-the-art equipment are stored behind the steel doors and are brought out only when work begins.

[2] The film cans of a freelance film producer working from home are stacked into useful display plinths, adding an "industrial chic" look to her apartment.

[3] Redundant vintage equipment can make attractive decorative features in a modern office, and serve as a stark contrast to the technology of today. Office equipment from the 1950s and earlier is now much sought after by collectors.

2

3

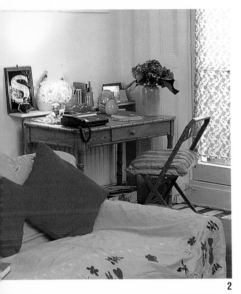

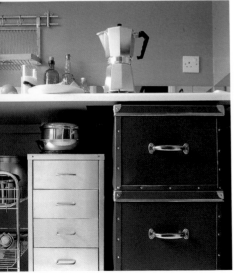

[1] To prevent wrist and neck injuries you should use a comfortable chair that is the right height for the desk or table at which you are working. This retro vinyl office chair was a lucky find in a street, saved from the fate of a rubbish dump.

[2] Part of your living room might have to be designated as an office area. Try to make it blend in by incorporating similar-style furniture.

[3] Plenty of storage space for office equipment is essential. Here a filing cabinet and attractive boxes find a discreet but accessible niche beneath a kitchen countertop.

[4] One of the advantages of working from home is that your office area no longer has to look corporate and uninspiring. Novelty touches like the "lips" telephone make work more fun.

[5] You will have to be very resourceful if space is limited. Using practical chairs like these fold-up cafe ones means that the office can be a temporary arrangement in your living room or kitchen.

For many people, it has always been more economical and advantageous to work from home, particularly those in creative professions. Now, however, with the advent of new technology such as personal and laptop computers, mobile phones, e-mail and Internet access, and the fact that the majority of business is carried out via these processes, the doors have opened for a new breed of home office workers.

The size of your office will depend on the size of your home and the type of work you do. Some people may have the luxury of a spare room that they can work in. This is obviously the ideal situation, not just from the point of view of space but also because when you finish work you can walk out and shut the door behind you.

It is far more likely, however, particularly for urban dwellers, that the office will have to be situated in a corner of the living room or kitchen. If this is the case, then you will have to be extremely resourceful, not only to make the most of the space available but also to prevent it from spreading out and intruding into the rest of your valuable living areas. It is very important that your mind be kept clear of work once you have finished, allowing you to relax and unwind properly.

Although the work area will need to accommodate aspects such as a business telephone, filing system, desk, chair, computer, printer and stationery, to name but a few, they do not have to be housed in traditional business furniture. One of the big advantages of having a home office is that you are not restricted to corporate uniformity as you would be in a regular office situation. Make it a fun place to work, but not distracting. Whether it is bright and colorful, all white, or chic black and chrome, ultimately it should claim to be inspiring, harmonious and efficiently laid out.

Try not to commandeer the kitchen or dining table as your work desk. Having to clear up before every meal is not an efficient way to work. It is far better to have a permanent desk or work surface, even if it is used only a few days each week. A good compromise solution is a trestle table, which can be temporarily stored when you are not working. It can be similarly stowed away when guests are coming over and you need more space in your living room.

Part of the problem of the modern office is the technology that we cannot avoid. Computers, printers, telephones and fax machines are all essential pieces of equipment, but they are hardly objets d'art. Just like the television set in our living room, they are bulky, usually fairly ugly, and rarely suit our interior decor. They therefore tend to stick out like a sore thumb, especially if you have a distinct period style in your home. The answer is to try to hide or disguise your technology, either by incorporating it into antique or interesting pieces of furniture or by using a small, decorative screen that you can unfold across your office area at night when you finish. This is not really necessary if your office is in a separate room or annex in your home, but should apply to areas where you are stealing space from a living room or kitchen in which you will spend a lot of time when not working.

Streamline your office working area as much as possible. Lots of visible files and paperwork will make it look cluttered, so make sure you have enough storage

facilities. If you do not have a built-in cupboard or cabinet for the purpose, create more storage space with attractive pieces of furniture. Chests of drawers, stacked trunks and even linen closets can all hide unsightly paperwork and other office paraphernalia.

There are homes, however, where technology does not look out of place. Some of the computers available today finally have an element of dynamic styling and come in a range of colors far more inspiring than sludgy white. These can actually look attractive in a trendy, futuristic way, and therefore suit the modern urban home to the point that they can even be considered a fashion accessory, not to be hidden away.

4

5

COLLECTING

AND **DISPLAY**

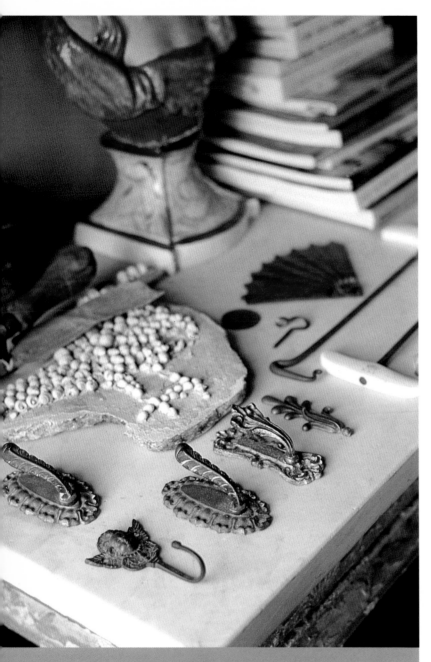

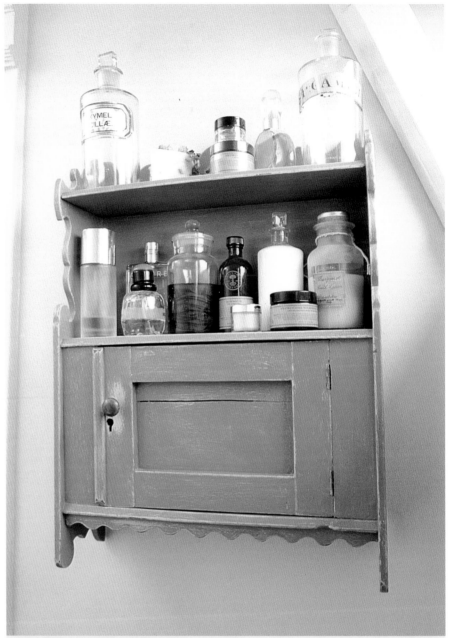

HOOKS ANY ITEM CAN BE TURNED INTO AN INTERESTING COLLECTION MERELY BY GIVING THEM A SPECIAL AREA OF THEIR OWN. ORNATE COAT- AND PICTURE-HOOKS, CAREFULLY LAID OUT ON A BEDROOM PIER TABLE, ASSUME AN IDENTITY OF PRECIOUSNESS AND GREAT VALUE.

BOTTLES THE BEGINNINGS OF AN APPROPRIATE COLLECTION ARE FORMING ON THIS COUNTRY-STYLE BATHROOM CABINET. INSPIRED BY THE RETRO PACKAGING OF MODERN PRODUCTS, OLD APOTHECARY BOTTLES HAVE BEEN ADDED TO ENHANCE THE EFFECT.

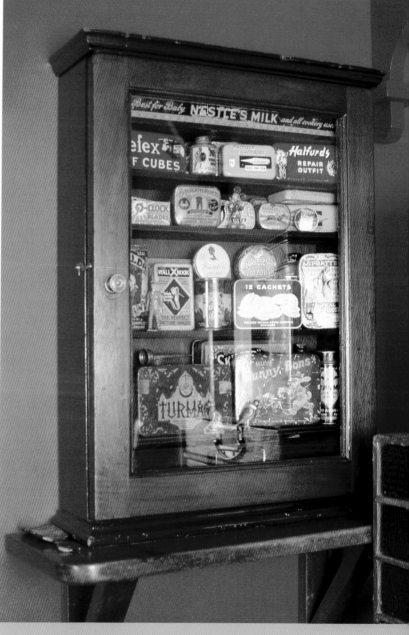

BOOKS ARRANGING AN ASSORTMENT OF OBJECTS TOGETHER WILL CREATE A FASCINATING STILL-LIFE FOR YOUR ROOM. THE WORN AND TATTERED BOOK COVERS BLEND WELL WITH THE SURROUNDING SUBTLE-COLORED WALLS AND WEATHERED TEXTURE OF ORNAMENTAL STONEWORK.

CANS CABINETS NOT ONLY KEEP OBJECTS CLEAN BUT ALSO RESTRICT THE SPREAD OF THE COLLECTION. VINTAGE CANS AND PACKAGING MAKE COLORFUL CONTENTS IN A VICTORIAN MEDICINE CABINET.

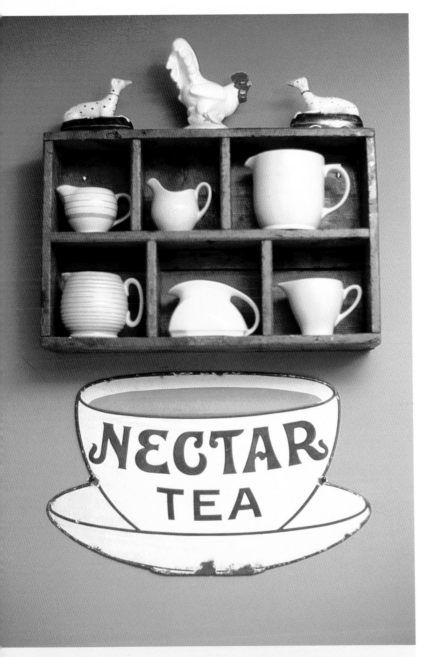

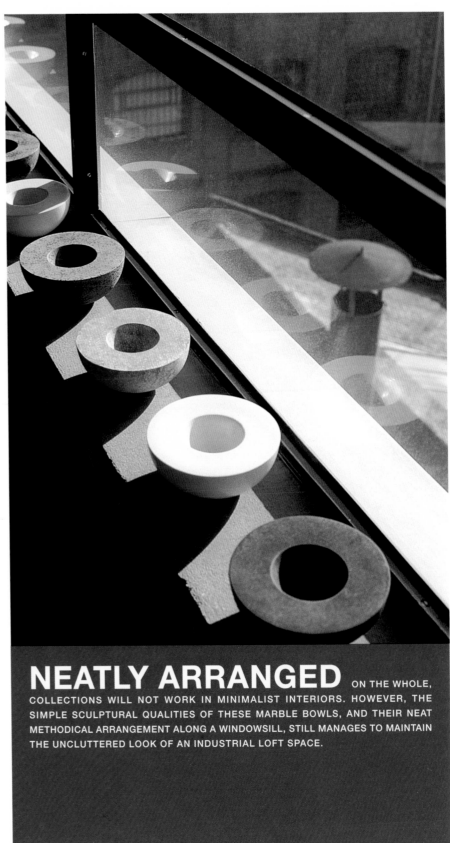

IN A BOX OR TRAY
A SUBDIVIDED BOX OR TRAY IS A SIMPLE WAY TO DISPLAY A COLLECTION. MILK JUGS BOUGHT FROM FLEA MARKETS AND JUNK SHOPS ARE GROUPED TOGETHER TO GIVE AN URBAN KITCHEN A COUNTRY-HOME FEEL.

NEATLY ARRANGED
ON THE WHOLE, COLLECTIONS WILL NOT WORK IN MINIMALIST INTERIORS. HOWEVER, THE SIMPLE SCULPTURAL QUALITIES OF THESE MARBLE BOWLS, AND THEIR NEAT METHODICAL ARRANGEMENT ALONG A WINDOWSILL, STILL MANAGES TO MAINTAIN THE UNCLUTTERED LOOK OF AN INDUSTRIAL LOFT SPACE.

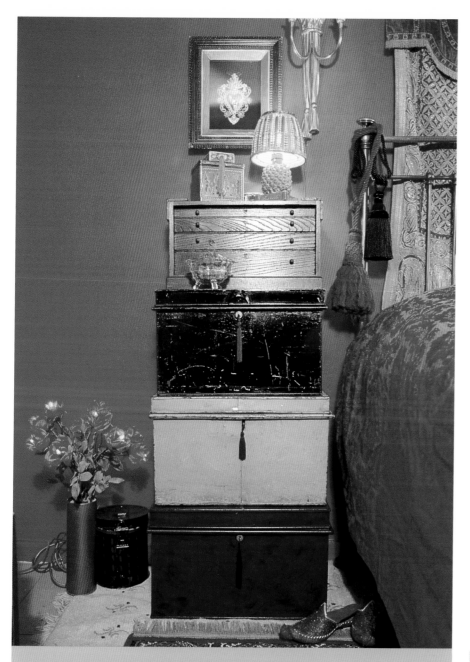

AS STORAGE SPACE STACKED
TRUNKS AND VINTAGE LUGGAGE HAVE BECOME AN ATTRACTIVE COLLECTION
WHILE PROVIDING EXTRA STORAGE SPACE IN A SMALL URBAN BEDROOM.

IN AN IMAGINATIVE WAY
ONE SOLUTION TO STORAGE PROBLEMS IS TO TURN PERSONAL POS-
SESSIONS INTO A DISPLAYED COLLECTION. WHEN PRESENTED IN AN
IMAGINATIVE WAY, LIKE THESE SHOES PERCHED ON A STEPLADDER,
PRACTICAL HOUSEHOLD ITEMS CAN MAKE AN ATTRACTIVE FOCAL POINT.

HISTORY OF COLLECTING

Collections have always formed an integral part of home interiors. We have a natural fascination for the new or the unusual, and an instinct to preserve or collect part of it, either for our own pleasure or as a way to teach or impress others. During the sixteenth and seventeenth centuries, collections were based on unique and exotic objects that were rare or had never been seen before. As the unchartered world was being explored and mapped for the first time, sailors and scholars brought back souvenirs from faraway lands. These were mainly examples of natural history, such as crystals, birds' eggs, seashells, tusks, horns and antlers, which were coveted and displayed to astound and astonish those who could never afford or were too frightened to travel.

Some of these objects were considered so amazing that they were turned into precious and fanciful objets d'art, mounted with silver, gold and precious stones. The wealthy sought to impress and outshine their equally rich friends with their collections of curios housed in grand cabinets that had been specially commissioned, often decorated with inlaid marble, marquetry or mother-of-pearl.

By the nineteenth century, in the age of Darwinism and the fascination with the origins of man, natural-history collecting was a consuming pastime. It was still a luxury of the middle and upper classes, who, having made their fortunes in the industrial revolution, found they had more leisure time to occupy. Being able to afford to travel meant they could constantly build on their collections of butterflies, birds' eggs, fossils and beetles, proudly displaying them in custom-built specimen cases.

[1] An old tool cabinet provides a fitting display area for a collection of garden planters that have been decorated with broken pieces of china salvaged from the river next to this warehouse loft. It evokes the mood of a dusty old garden shed in this corner of the apartment.

[2] Collections add a personal touch to an interior. Here, souvenirs from Mexico are lovingly displayed around a bedroom mirror.

STARTING A COLLECTION

Today, anyone can start a collection with just about any kind of item—car sparkplugs, matchbox labels or plastic characters that came free out of a cereal box, for example. When grouped together and given their own niche or display area, they will invariably evoke memories of those collectors of curiosities of the 1600s.

A collection can be an investment, an obsession or merely a decorative feature of a room's interior. It can be made up from souvenirs brought back from your vacation, objects found on a beach or woodland walk or items that you actively seek out at flea markets and junk shops.

A collection begins either by accident or by intention—perhaps by casually picking up striking-looking pebbles or driftwood each time you walk along a beach, and then arranging them on a mantelpiece or windowsill, or by deciding that your retro 1940s-style kitchen would look more authentic with a collection of old enamel saucepans on the wall. Unlike the curio collections of our ancestors, these collections are more of a style statement than a display of wealth and materialism.

Why one person is drawn to a pebble and another to an enamel saucepan is just a matter of personal taste, and in this respect a collection of objects is another reflection of the owner's character within an interior.

The grouping of objects together, whether they are alike or share something in common, can add an aesthetic touch to an interior—sometimes whimsical, sometimes dramatic—and enhances the mood or flavor of the interior style you are trying to create. It is very fashionable nowadays, particularly in modern loft apartments, to feature a collection of battered and bruised everyday objects to offset the modern, clean look. Old garden tools hung on a wall, dressmaker's dummies strategically placed around a living room, or vintage leather luggage stacked at the bottom of a bed—all add a characterful element to space that previously had none.

Pieces that make up your collection might be chosen for their sentimental qualities, or because they spark a passion inside you with their design, color or texture. They might be entirely nostalgic and play a key role in setting the tone or atmosphere for a period style.

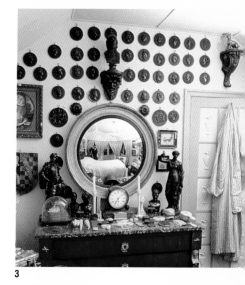

3

DISPLAYING YOUR COLLECTION

A small collection looks best when it is slightly isolated or given pride of place, whether it is on a shelf or in a corner of the room. Alternatively, dedicate a piece of furniture, such as a glass cabinet or chest of specimen drawers, to your collection. Not only does this make it appear more precious but it also keeps it confined; otherwise it is quite easy for collections to spread out and take over.

The way you display and arrange your collection is as important, if not more so, as the objects themselves. It can make or break the effect your collection has on the room. Objets trouvés look best when laid out in a random, lackadaisical grouping, while classical prints or wall plaques require a more symmetrical and formal arrangement.

Some collections do not start off as such, but naturally evolve out of necessity. When storage space is limited, you will have to be resourceful in devising solutions to the problem. Old tin trunks and vintage luggage can hide away some of your clutter and clothes and become an attractive feature when stacked creatively in a room. Similarly, use baskets, trays and jars to store items and then display them as integral parts of the interior.

Other solutions to your storage problems might be to display the actual storage material in such a way that it takes on the mantle of "collection" itself. Personal items such as clothes, shoes and hats can donate their colors and textures to an interior while expressing another element of the owner's personality within their unique urban space.

4

[3] The objects themselves can determine the way they are grouped together or displayed. These wall medallions are hung on a bedroom wall in a precise and formal manner to accentuate their classical attributes.

[4] A resourceful new use for old. Glass jars provide elegant storage for bathroom products such as cotton balls.

[5] Furniture can be both functional and aesthetic. This handsome haberdasher's cabinet turns practical clothes storage into an intriguing display.

5

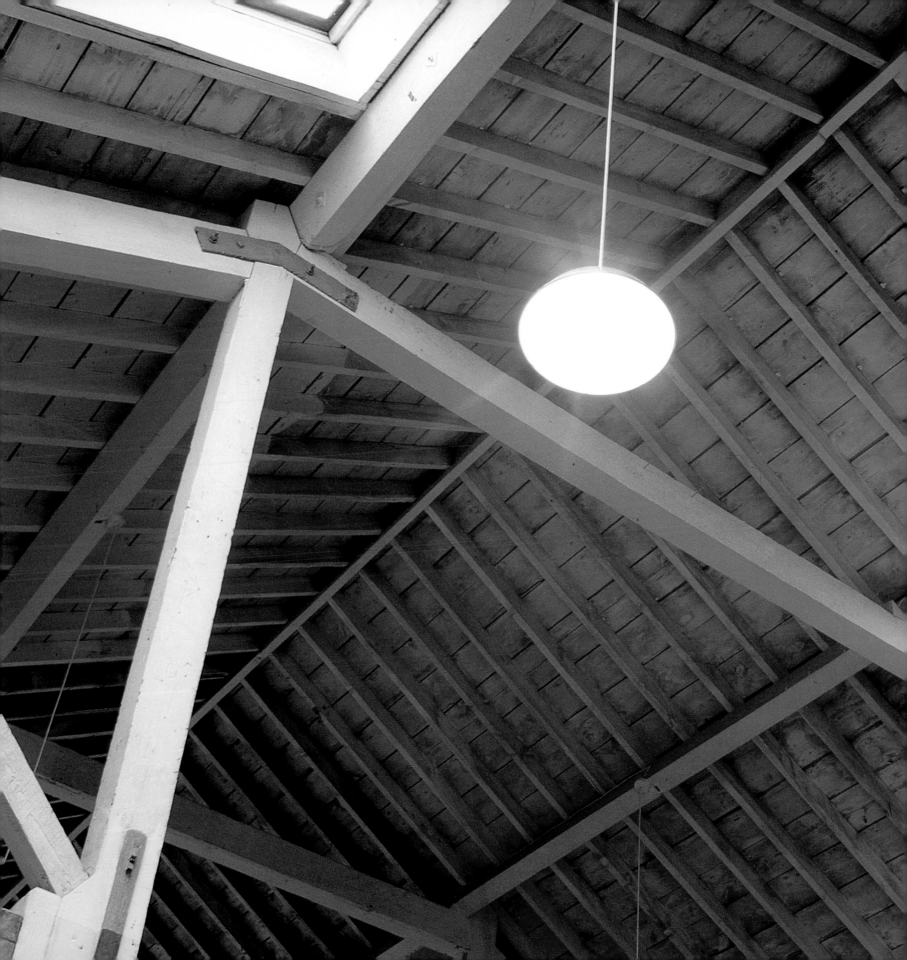

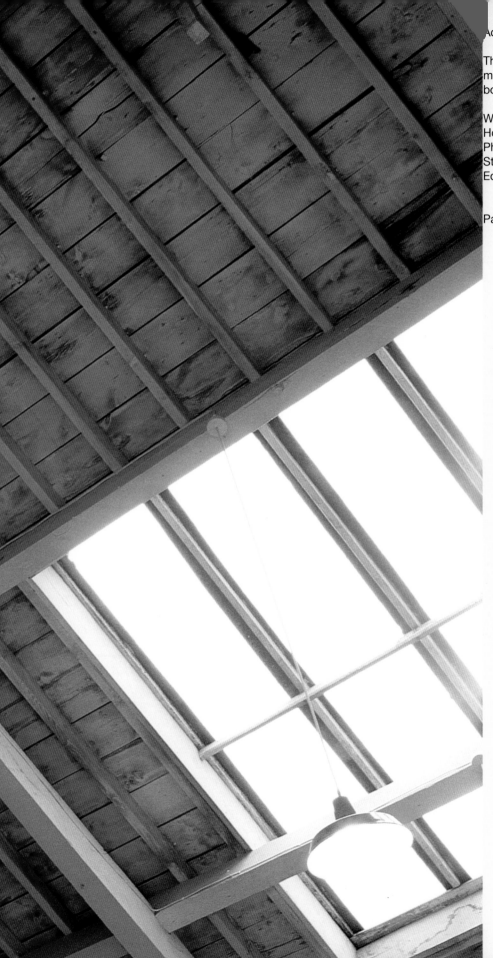

Acknowledgments

The author would like to thank all the following for their kind permission to photograph their homes and premises for use in this book:

Wendy Gay, Jill Everett, Sonia De Marcos and Spencer Gunn, Peter Hone, Anthony Reeves at Lassco, Paul Steers, Thomas Kibling, Phil Cowan at Boom!, Sarah Ellis and Sam Robinson at the Cross Stefan Shulte, Fiona Pow, Geoff Westland at Westland & Co., Edison Abidi, Nick Lloyd at Aquatic Design

Paintings on page 24 by Alison Watt

A

ADVERTISING 11
ANTIQUE SHOPS 19, 103
ARCHITECTS 12
ARCHITECTURAL SALVAGE
 YARDS 13, 17, 18, 18,
 19, 29, 45, 46, 49, 61,
 62, 76, 93, 105
ARCHITECTURE 10, 58
ARCHITRAVING 26, 61
ART DECO 12, 39, 40, 104
ART GALLERIES 8, 11
ART GALLERY STYLE 24–29,
 29
AUCTION ROOMS 61, 62,
 103

B

BAROQUE 12, 82
BASEBOARDS 26, 61
BAUHAUS STYLE 41
BATH ROLLTOP 104, 105
BATHROOMS 77, 104–111
 CUSTOMIZING 106
 FITTINGS 19, 110
 GLOBAL STYLE 108–
 109
 GROTTO STYLE 106–
 107
 INDUSTRIAL CHIC 110–
 111
 MINIMALIST ART
 GALLERY STYLE
 104–105
BEDROOMS 96–103
 CLASSICAL PERIOD
 STYLE 102–103
 INDUSTRIAL CHIC 98–
 99
 OPULENT PERIOD
 STYLE 96–97
 WAREHOUSE RUSTIC
 100–101
BEDSPREADS 102, 103
BELFAST SINK 91
BOHEMIAN ECLECTIC
 STYLE 30–35
BOOKCASE 74
BREAKFAST BAR 94
BRICK, EXPOSED 39, 40,
 46–47

C

CABINETS 119, 119
CACTI 50, 55, 80
CAFES 12
CANDELABRAS 82, 82
CANDLE LIGHT 49
CARPET 12, 68
CEILINGS 32, 39, 39
CHAIRS 72–73, 82, 97
 BAMBOO ARMCHAIR
 61
 CHARLES EAMES 43
 CINEMA SEATS 13, 48
 DINING CHAIRS 83
 LE CORBUSIER 41
 OFFICE CHAIRS 68, 68,
 85, 85, 114
 PARQUET 25, 67
 STACKING CHAIRS 68,
 115
 VINYL ARMCHAIR 32
 WICKER CHAIRS 80, 81
CHAISE LONGUE 38
CHECKERED PATTERNS 32,
 32, 109
CHINESE STYLE 61
CLADDING 49
CLAPBOARDING 94
CLASSICAL STYLE 56–63
CLOCK TOWERS 18
COLLECTING 58, 116–123
COLOR
 SCHEMES/PALETTES
 13, 15
 HERITAGE RANGE 103
 MONOCHROMATIC 58
 CONTEMPORARY
 STYLE 68–69
CORNICING 26, 61
CROCKERY 81, 82
CUTLERY 82

D

DESKS 114
DIVIDERS 18, 48, 74
DIY SHOPS 19
DOORS 26, 103
 FITTINGS 12
 GLASS-PANELED 46,
 49, 72
DUMPSTERS 12, 18, 46,
 61, 62, 68, 106

E

E-COMMERCE 8
ENGRAVING 61

F

FENG SHUI 71, 75, 75
FIREPLACE 42, 26, 53, 67
FISH TANKS 75
FLOORING
 AFRICAN SLATE FLOOR
 TILES 94
 NATURAL FIBER 64, 68
 PAINTED FLOOR
 BOARDS 31, 32, 33, 35,
 77
 PARQUET 25, 67
 POLISHED TIMBER 39
 RAISED FLOOR 73
 RUSTIC 17
 TERRACOTTA TILES 89,
 91
 TIMBER 26, 26, 58, 63,
 86, 110
FOUND ITEMS 12, 46,
 48, 83
FUNCTIONALISM 85
FURNITURE
 CUSTOMIZED 35, 54,
 66
 FUNCTIONAL 24, 26,
 123
 GEORGIAN 56, 61
 LLOYD LOOM 72
 OFFICE 42, 43, 65
 REPRODUCTION 61
 FUTURISTIC STYLE 19

G

GARBAGE CANS 14, 19, 95
GARDENS 26
GATES, IRON 13, 76
GAZEBOS 18
GEORGIAN TOWNHOUSE
 8, 16
GLASS BRICKS 40, 40, 41,
 71, 74, 76, 76, 99
GLASS BUILDINGS 8
GLOBAL STYLE 19, 51–55
GOTHIC STYLE 61
GREEK INFLUENCE 56–59,
 61

H

HARDWARE SHOPS 19
HOME OFFICE 66, 112,
 112–115, 113

I

INCENSE 55
INDUSTRIAL CHIC 11,
 37–43, 88, 113
INDUSTRIAL PROPERTIES
 8, 39
INSPIRATION 6, 10–19, 13,
 29, 39

J

JUNK SHOPS 29, 46, 48, 61,
 62, 97, 103, 120, 122

K

KITCHENS 76, 85, 88–95
 1940S RETRO STYLE
 91, 122
 CLASSICAL 90–91
 CREATING AN
 INDIVIDUAL LOOK 94,
 94, 95
 CUSTOMIZING 93
 FITTED 89, 90, 93
 FREESTANDING 89,
 90–91
 MINIMALIST ART
 GALLERY 88–89
 MODERN RETRO 92–93
 PERIOD 90–91
 PROVENÇAL STYLE 90
 WAREHOUSE RUSTIC
 94–95

L

LARSON, KARL 11
LEATHER FURNITURE 40,
 42, 43, 68
LIGHTING 25, 26, 40, 55,
 97, 99, 109, 110
 1930S STYLE GLOBE
 LIGHT FIXTURE 93
 ALABASTER
 UPLIGHTER 63
 ART DECO CEILING
 LIGHTS 49
 HALOGEN SPOT
 LIGHTS 29, 75
 JAPANESE PAPER
 LANTERN 85
 LAVA LAMP 69
 METAL LANTERNS 55,
 RECESSED 11
 SOFT AND AMBIENT 35,
 35, 62
 SPACE AGE LAMPS 69
 STANDARD LAMP 42
 TABLE LAMP 49, 67, 69
 TIZIO LAMP 42
 VICTORIAN OIL LAMP
 49
LIMED EFFECT 61
LIVING AND DINING AREAS
 74, 80–87
 CLASSICAL 86–87
 GLOBAL STYLE 80–81
 INDUSTRIAL CHIC
 84–85
 WAREHOUSE RUSTIC
 82–83
LOFT APARTMENTS 19, 37,
 40–41, 46–47, 49, 62, 72,
 77, 110, 123
LOFT CONVERSIONS 75
LOUVER SHUTTERS 55
LUMBER YARDS 17, 18,
 19, 40

M

MARBLE 12
MARKETS 18, 18, 19, 49, 54,
 61, 93, 97, 103, 120, 122
METAL WORK 94
MEXICAN INFLUENCE 18,
 52, 55, 81, 122
MEZZANINE LEVEL 77, 94,
 100
MINIMALISM 11, 26, 98, 110
MIRROR 32, 35,
 INFLUENCE 56–59, 59,
 62
MOROCCAN STYLE 52, 109
MOSAICS 11, 16, 106, 109
MUSEUMS 11, 12, 95
MUSLIN CURTAINS 32, 100,
 101

N

NAUTICAL INFLUENCE 48
NEOCLASSICISM 58
NEW YORK INFLUENCE 39,
 46

O

OBJETS D'ART 9, 86, 103,
 114, 122

P

PAINTWORK, DISTRESSED
 35
PANELING 12
PARTITIONS SEE DIVIDERS
PIANO 27
PLANTS AND FLOWERS 52,
 54, 86
PLASTERWORK 12, 55–56,
 58–59, 62, 86
PLASTIC GOODS 81

R

RADIATOR 25, 40
RAW MATERIALS 10, 11
RECYCLING 12
REFERENCE MATERIAL 95
RETRO STYLE 19, 66
RIVERSIDE HOMES 45
ROCOCO PALACES 8
ROCOCO STYLE 106
ROLLER BLINDS 69
ROMAN INFLUENCE 56–59,
 61
RUGS 35, 52, 54, 58, 67, 68

S

SANDBLASTED GLASS 11
SCREENS 69, 73, 74, 99, 114
SHELVING 12, 106
SHOWER 110, 111
SHUTTERS 61, 75, 105
SKYLIGHTS 44
SOFA 32, 33, 36
SOFA BED 98
SOFT MODERNISM STYLE
 64–69
SPACE, MAXIMIZING 70–77
STAINED GLASS 18, 19, 104,
 105
STAIRCASE 46
STENCILS 54
STORAGE 31, 35, 68, 74–75,
 89, 91, 115, 115, 121,
 123
STOVE 89
STUDIO APARTMENTS 74,
 77
STYLE PALETTE 20–69
SWEDISH COUNTRY
 LOOK 12

T

TABLE SOCCER 35

TABLES 68, 80, 81, 82, 83, 85, 87, 89, 114

TAG SALES 49, 97, 103

TELEPHONE 99, 115

TELEVISION SET 87

TIKKI-POLYNESIAN STYLE 54

TILING 106, 108, 109

TOILE DE JOUY CUSHION 86

U

URBAN CHIC 9, 11, 32

URBAN LIVING 8–9

URBAN REGENERATION 8, 39

V

VACATION PURCHASES 54

VASES 49, 61

VENETIAN BLINDS 55, 109

W

WALLS, RUSTICATED 81

WARDROBE 32, 54

WAREHOUSE LOFT 100

WAREHOUSE, RUSTIC 44–49

WATER FOUNTAINS 18

WHITE WALLS 26, 66, 98

WINDOWS 36, 48, 49, 65, 82, 94

 CAST IRON 29

Acknowledgments in Source Order

Apply Pictures 4–5
Octopus Publishing Group Ltd./*Mark Kitchen-Smith* 13 right, 14, 48 bottom left, 49 bottom

/*Tom Mannion* front cover, back cover left, back cover center left, back cover center right, back cover top right, back cover top center right, back cover top center left, back cover bottom center right, back cover bottom center left, 2–3, 6, 9, 12 top, 13 left, 16, 17, 18 top, 24, 25 main picture, 25 top right, 25 bottom, 26 top, 26 center, 26 bottom, 27, 28, 29 top, 29 center, 29 bottom, 30, 31 left, 31 right, 33, 34 right, 35 center, 35 bottom, 36, 37, 38, 39 top, 40 left, 40 right, 41 left, 41 right, 42, 43, 44, 45 top, 45 bottom, 46 bottom, 47, 48 top center, 48 top right, 48 bottom right, 55 top, 56, 57, 58, 59, 61 top, 61 bottom, 62 top, 62 center, 62 bottom, 63 top left, 63 top right, 63 bottom left, 64, 65, 66, 66–67, 67 left, 67 right, 68 top, 68 center, 68 bottom, 69 top, 69 center, 69 bottom right, 71 left, 71 right, 72 left, 72 right, 73 left, 73 right, 74 top, 74 bottom, 75, 76 top, 76 center, 76 bottom, 77 top, 77 bottom, 83 main picture, 83 center right, 84, 85 center, 85 bottom, 86 top, 86 center, 87 main picture, 87 top right, 88 main picture, 88 top right, 88 bottom right, 89 top, 89 center, 89 bottom, 90 top, 90 center, 90 bottom, 91 bottom left, 91 bottom right, 92 main picture, 92 top left, 92 center left, 92 bottom left, 93 top, 93 center, 93 bottom, 94 top, 94 center, 95 left, 95 center right, 95 bottom right, 96 left, 96 top right, 96 bottom right, 97 top right, 97 center right, 97 bottom right, 98, 99 top right, 99 bottom left, 99 bottom right, 100 top left, 101, 102, 103 top, 103 center, 103 bottom, 104 main picture, 104 top right, 104 bottom right, 105, 106 center, 107, 110 top, 110 center, 110 bottom, 111, 114 center, 114 bottom, 115 left, 115 right, 117 left, 117 right, 117 center, 118 left, 118 right, 119 left, 119 right, 120 left, 120 right, 121 left, 121 right, 122 top, 123 top, 123 center, 123 bottom

/*Mark Winwood* back cover top left, back cover bottom left, 7, 8, 10, 11 top, 11 center, 11 bottom, 12 center, 12 bottom, 15, 18 center, 18 bottom, 32 top, 32 center, 32 bottom, 34 left, 35 top, 39 center, 39 bottom, 46 top, 48 top, 48 bottom center, 49 top, 52 top, 52 center, 52 bottom, 60, 61 center, 81 top, 82 top, 82 center, 82 bottom, 83 top right, 83 bottom right, 85 top, 87 bottom right, 91 top, 95 top right, 100 center left, 100 bottom left, 106 top, 106 bottom, 112, 112–113, 113, 114 top, 128

/*Mel Yates* back cover right, 50, 51, 53, 54 top, 54 center, 54 bottom, 55 center, 55 bottom, 80 main picture, 80 top right, 80 bottom right, 81 center, 81 bottom, 108, 109 top, 109 center, 109 bottom, 122 bottom
Images Color Library Limited 20
Photodisc 22
Tony Stone Images 78–79